North American Indian Designs

EVA WILSON

A COLONNADE BOOK

Published by British Museum Publications

© 1984 Eva Wilson

Second impression 1990

Published by British Museum
Publications Ltd
46 Bloomsbury Street, London
WC1B 3QQ

British Library Cataloguing in
Publication Data
Wilson, Eva
North American Indian
designs.____(British Museum pattern
books; 2)____(A Colonnade book)
1. Indians of North America ____ Art
I. Title II. Series
745.4′41 E98.A7

ISBN 0 7141 8055 6

Designed by Roger Davies

Printed in Great Britain at
The Bath Press, Avon

Acknowledgement
I am most grateful to the staff of
the Department of Ethnography
in the British Museum
(Museum of Mankind) for
making material available to
me. In particular I would like to
thank Jonathan King, Assistant
Keeper in the department, for
his help and encouragement
throughout the work on this
book.

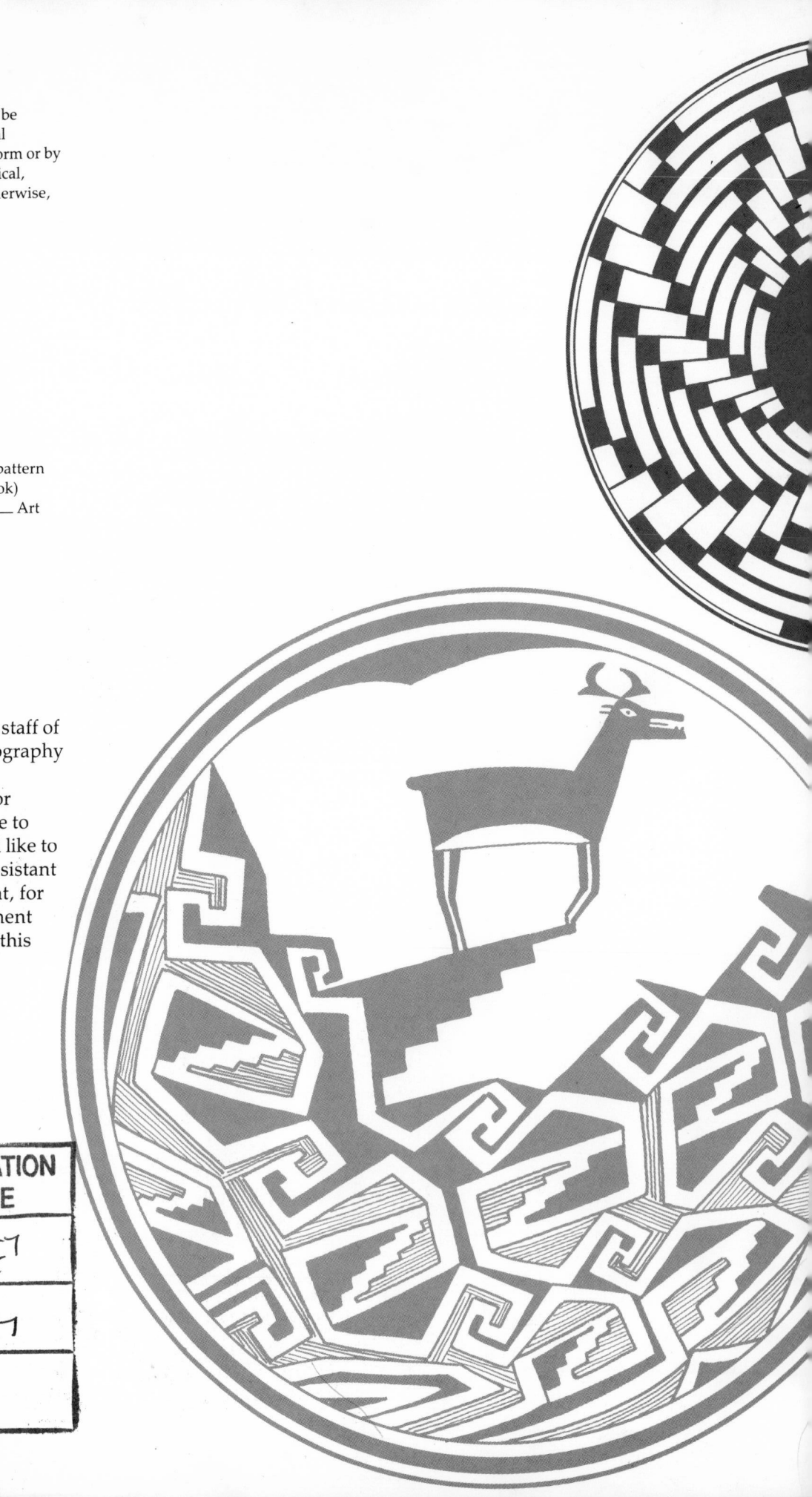

Contents

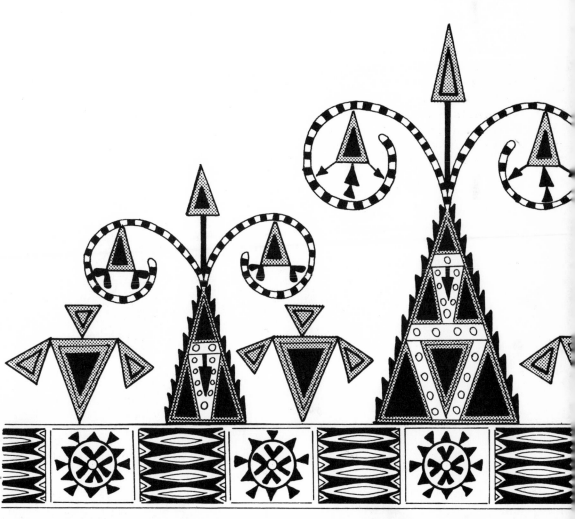

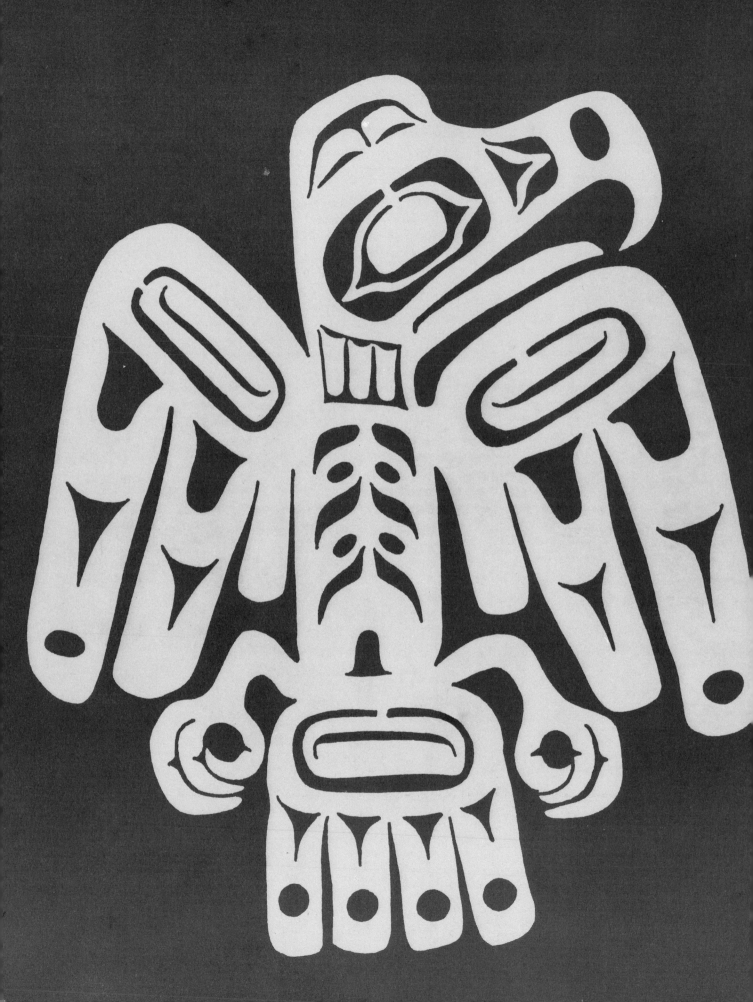

Introduction

And in all the days of my life I have not seen anything that so gladdened my heart as these things did. For I saw among them wonderful, artificial things and marvelled at the subtle ingenuity of people in strange lands.

This is what Albrecht Dürer is reported to have said when he saw the treasures brought back from Mexico by Cortes in 1520. Although the objects acquired in North America by the early explorers were less spectacular, they were received in Europe with enthusiasm. Significant collections were built up in Western and Northern Europe in the seventeenth century. But this very enthusiasm and collecting zeal soon brought about changes in the art itself.

Before the Indians in North America had been visited by Europeans their art had been produced for themselves alone. It not only served as decoration on objects in everyday use but was also an integral part of the beliefs which permeated their lives. It is possible to identify some basic religious concepts which were common to most North American Indians. One such idea was the belief that spirits inhabited the natural world and had the power to influence events. The belief in the sacred nature of all things was expressed in ritual practices, which were part of everyday life, and in art, which was thought to influence the spirits. This was particularly true of hunting and fishing: images on clothing, weapons and tools could invoke the good will of the animal spirits. Another way of manipulating the forces of nature was the dream, or vision, through which men could achieve special contact with guardian spirits, often in animal form. The images of these animals became the distinguishing symbol of a man, a group or clan.

As it became apparent that such objects could be used for trade with the Europeans and exchanged for valuable goods, a different consideration emerged in the production of art — the desire to please these new customers. To the scholar for whom this art is interesting as an expression of the Indian's lifestyle and beliefs, this is a matter for regret. Not so, however, for anyone who wishes 'to marvel at the subtle ingenuity of people in strange lands'. That is the intention of this collection. Good patterns, whether prehistoric or modern, and produced for whatever purpose, remain good patterns. And good patterns, simple, ingenious or subtle, are the main theme of this book.

The material is primarily based on designs from pottery, basketry, weaving and embroidery, and to a lesser extent on carvings, painting and metalwork.

Two main types of pattern-making and design have become apparent: in the first group are patterns, mainly geometrical, which arise naturally from techniques like basketry and weaving, and in the second are designs based on particular motifs — often of symbolic, magical or heraldic significance — which are adapted to the requirements of the medium in which they are expressed. (The Thunderbird, for instance, takes on very different shapes in quill work, basketry and carving (**39, 78 — 80**).) In the second group of designs the techniques of the medium are sometimes stretched almost beyond their limits to accommodate the motifs. The supreme example is the Chilkat blanket (**72 — 73**), where weaving techniques had to be invented to interpret in textile the strict conventions of the art of the North-west Coast: the techniques were so

arduous that it has been calculated that it took a woman six months to weave a single blanket and another woman as long to spin the yarn.

Most of the art illustrated here was created by women who were traditionally basket-makers, weavers and potters; men generally carved and painted, although there are exceptions to this rule.

It is typical of North American Indian art that the pattern elements and design motifs are fairly limited in number, but also that they are repeated with many variations, which are characteristic of particular groups and even individual craftsmen. There is a remarkable consistency in the general style from prehistoric to modern times, and old patterns were often revived.

This may be due to the particular circumstances of the Indian people in the last couple of hundred years. Initially European contact acted as a stimulus to arts and crafts as a result of expanding trade and the introduction of new technology. But in time the effects of European settlement proved disastrous as Indian nations were dispersed, their people decimated by diseases for which they had no immunity, and their culture was deliberately suppressed. Tribal art serving tribal needs virtually disappeared, and with it natural growth and renewal. The traditions of craftsmanship survived mainly to serve tourists and collectors of Indian art. The traditional styles which survived were therefore often those which these customers favoured. Thus it is not surprising that, while some of these products were good, many more were of bad quality, technically and artistically.

In the twentieth century political changes have encouraged a new confidence and a renaissance of culture among the Indian people and in this more favourable climate art has again begun to develop and grow. Schools for Indian art have been established. As a result gifted artists have emerged who have successfully revived old techniques and forms with tribal characteristics, particularly in pottery. This has been further encouraged by finds from archaeological excavations, focusing interest on the art from remote periods of the Indians' past. More recent techniques like silver-smithing have also been developed to high standards. Equally a non-tribal pan-American art has emerged, producing individual artists who are in the mainstream of modern art while retaining an Indian identity.

Although this collection of patterns and designs is intended to be enjoyed by anybody with a general interest in art, it is hoped that those engaged in design, whether amateur or professional, will also find inspiration among its pages. In this introduction a short account of the origins of the North American Indians is followed by notes on the principal developments in arts and crafts, with particular reference to the techniques used in pottery, basketry, weaving etc. A list of books on more specialized topics is added at the end.

The Origins of the North American Indians

The native Americans were a single people of a mixed Asian stock who, over a period of thousands of years, developed many different cultures and languages in response to a variety of geographical and climatic circumstances without significant contact with the rest of the world. It is

customary to regard the time before they made contact with people from other continents as prehistory. The historic period in North America therefore begins at different times in different areas. Thus in coastal areas of the South-east the historic period begins with the arrival of the Spaniards in the sixteenth century. In the North-east it begins with the establishment of colonies by the Dutch, British and French in the seventeenth century and in the North-west in the eighteenth century with the visits of Spanish and British explorers such as Captain James Cook. In the interior and in isolated communities, this contact occurred at much later dates.

During the last Ice Age the sea level dropped as large quantities of water remained frozen in the glaciers which covered large areas of the earth. However, they did not form continuous ice caps and tracts of previously submerged land were exposed. At various times parts of Siberia, Alaska and western Canada were virtually free of ice and were connected by a land bridge across what is now known as the Bering Sea.

The first men crossed over this land bridge to the American continent from Asia, following the movements of the large mammals which they hunted, and continued to follow them on their southward migrations. When the glaciers began to melt some ten thousand years ago the land bridge was again submerged by the sea.

The climatic changes and rising temperatures which brought about the melting of the ice cap produced radical changes on the land; rivers and lakes formed in the north while some areas in the south dried out and the previously lush vegetation disappeared. One of the effects of these ecological changes was the extinction of mammals like the woolly mammoth and the giant mastodon. Man therefore had to find alternative means of subsistence, small-game hunting, fishing, gathering and, in time, agriculture. Cultivation combined with gathering and hunting encouraged a less nomadic lifestyle which led to a more diversified society and to population growth. These changes did not happen at the same time or in the same way everywhere across the North American continent; the various groups adapted to their particular circumstances and environments, developing a multitude of responses to their natural surroundings over a period of many thousands of years. The separate developments of isolated groups gave rise to the many tribes and numerous languages which met the Europeans when they first encountered the Indians in North America.

The far north, apart from the Bering Strait region, remained uninhabited until the recession of the glaciers allowed the slow movement of bands of hunters across Arctic Canada to Greenland. In these areas developed the highly specialized mode of life of the Eskimos.

The large area east of the Rocky Mountains, which ranges from the Arctic to the Mississippi and Missouri rivers, embraces a great variety of topographical features – forest, steppe and grassland – and the climatic conditions vary from sub-arctic through temperate to near tropical. However, the absence of natural barriers allowed population movement and the exchange of ideas, linking the many tribes living in this vast area in a shared heritage expressed particularly in their religious beliefs. Archaeological evidence suggests that in the post-glacial period there

were societies in these areas stable enough to devise elaborate burial cults.

The South-east

The large earthworks of the Adena and Hopewell cultures in the east are evidence of important cultural changes which took place with the development of agriculture from the ninth and eighth centuries BC. As the Hopewell culture declined in the fifth century AD, a new culture emerged in the Mississippi valley showing clear influences from the contemporary cultures of Middle America. The economy was agricultural and the towns were dominated by large mounds, some serving as ritual and administrative centres, others as burial places. The large size and complexity of these structures are the reflection of a highly organized society. Trade between different groups was an important feature and ritual objects are found over a wide area.

The objects found in the burial mounds of these early cultures are characterised by three-dimensional carving on figures and pipes (60) and by a fine linear style of engraving on shells, stone and copper (1,2). The pottery consisted of simple household ware as well as decorated ware of high quality.

The techniques of making, decorating and firing pottery in North America were basically the same in all the areas where it was produced, and indeed have hardly changed to this day. The process is simple: the vessels are hand-raised by the coiling method and fired in clamp kilns (the methods are described in more detail below p.19). The fact that the results are sometimes highly sophisticated and the quality superlative is not due to technical refinement but to the manual skill of the potters and the preparation of the natural clays.

The human and animal features added to some of the vessels recovered from the large mounds in the South-east suggest that they had a religious or symbolic significance (3). The purely decorative patterns are mainly based on scrolls, applied with a fine artistic sense. Indeed, it is difficult to imagine a more perfect example of harmony between shape and decoration than the vessel illustrated at 4 TOP. It is a feature of this style that the painted patterns leave a complementary, and sometimes dominant, pattern made up by the undecorated parts of the surface (negative painting) (4).

Textile fragments and impressions of cloth on pottery found in excavations demonstrate that twined and woven fabrics of vegetable fibre and animal hair have a long history in North America. The first Spanish and French explorers to arrive in the South-east described the method of weaving: warp threads were suspended from a cord stretched between two upright stakes. The weft was interlaced with the warp which was not held under tension. The fabric produced by this method was used for clothing as well as other domestic purposes. There is some evidence that a true loom with a simple shed was used in the South-east in the eighteenth century and may have been an indigenous invention.

The effects of the European settlement were particularly extreme in this area and the prehistoric art styles of the South-east did not continue into the art of the historic period, as did the iconography and images of

other tribes which enjoyed more continuity of cultural identity.

Among the crafts practised by the Indians of this area today is basketry. Using river cane and oak splints they produce baskets in simple chequer or twill plaiting; these methods are illustrated at **88** TOP. The most sophisticated examples of these baskets have double shells, interwoven at the rim, and patterns in diagonal plaiting (**88** BOTTOM). The natural colour differences between the inside and outside surface of the cane are used to create patterns, with the occasional addition of other colours from vegetable dyes.

The North-east

In the North-east the contact with the Europeans proved less immediately disastrous.

The historic period began in the early seventeenth century with the establishment of permanent trading centres by the French in the St Lawrence Valley. These were followed in 1616 by Dutch centres in the Hudson River Valley. The traders offered the Indians cloth, iron tools, brass kettles and liquor in return for furs, especially beaver skins. In the 1660s the English succeeded the Dutch, establishing trading posts in James Bay, part of Hudson Bay. In the course of the following century, the range of European goods brought to the Indians in return for their furs increased to include a variety of cloth, haberdashery, clothing, dyes, beads, weapons, sugar, tobacco, silver and much else. These goods did not only reach the Indians living near the trading posts, but penetrated deep into the continent through Indian middlemen who may have used and expanded the indigenous trade network.

The fur trade developed into a complex system in which Indian participation was not confined to supplying the furs and trading as middlemen, but also included gathering and producing food for the trading posts and supplying souvenirs for European visitors.

Broadly speaking, various motifs and styles based on ancient traditions are common to the art of this whole area. Two major art styles met and mixed in the woodlands area of the Great Lakes. One group had its prehistoric origin in the Ohio-Mississippi region and further south and was based on an agricultural lifestyle, while the other originated in the north of Canada and Siberia and was based on a nomadic lifestyle dependent on hunting. Over many centuries of contact, elements of these two groups became mixed.

The northern tradition is characterised by the use of the double-curve motif (**44, 45, 49 − 52**); by certain techniques like scraped birch-bark patterns (**44**), quill work and false moosehair embroidery (**37** TOP and CENTRE, **39** TOP, **40, 54**), and by the prominent use of bilateral symmetrical patterns used in asymmetrical compositions where, for instance, different patterns are used on opposite sides of moccasin cuffs (**55** TOP CENTRE) or on opposite sides of bags, pouches and sashes (**42** TOP LEFT and **43** TOP LEFT illustrate the designs on the front and back of the same sash). The bilateral symmetrical patterns are thought to have been created and developed by folding sheets of birch bark and biting through the folded layers. When the sheet was unfolded the bite marks made patterns of

this kind. Many of these sheets survive and are seen as experimental work serving as prototypes for new patterns.

The southern tradition is represented by a curvilinear, decorative style (**55** TOP LEFT) and by a naturalistic style of carving, particularly of faces, birds and other animals executed on pipes, masks and squatting figures.

The meeting of northern and southern elements is seen, for instance, in curvilinear patterns of bilateral symmetry which are very common in the art of this area (**48, 49**).

Other patterns were associated with the belief that spirits inhabited the natural world and closely controlled men's lives. The motifs decorating the objects and clothing used in daily life were often images of these spirits. While the individual or group could choose the spirit of an animal as their particular guardian, using its image on their belongings, these images cannot now be easily distinguished from the portrayal of animals for other purposes. There are, however, a number of supernatural beings whose identities are well known. Some are benign and belong to the Upper World, such as the Thunderbird which was associated with fertility, thunder and rain. The Thunderbird usually took the shape of an eagle-like bird and the designs often included zig-zag elements representing the lightning which it used to combat the evil forces of the Under World. A creature of the Under World was the Underwater Panther or Great Lynx, depicted with a long tail and horns to indicate its supernatural essence. Such images served to invoke these spirits (**36, 37, 39**).

One of the most important of the indigenous materials used to decorate articles of clothing and other objects made from skin were porcupine quills. The natural habitat of the porcupine is the Sub-Arctic, the mountainous areas of western North America and the northern parts of the North-east. However, quills were traded beyond these limits and were also used by many Plains tribes. The quills were softened in water and flattened; the white quills were dyed with vegetable or mineral substances, most commonly red, black, yellow and blue. Later other dyes were obtained through the European trade.

Using a variety of methods, patterned panels were produced and appliquéd to the objects they were to decorate. In the simplest method the flattened quills were wrapped round strips of leather or birch bark. Equally, there were many ways in which quills could be sewn to a backing of leather. Sinews were used as thread and the basic principle involved wrapping the quills round the thread and securing the work to the underlay by a simple spot stitch or back stitch. The quills were spliced by overlapping, and different coloured quills were introduced to create the pattern. The texture could be varied by folding or wrapping the quills over the thread in different ways, often folding the quill back and forth to hide the stitching. One such method is illustrated at **37** CENTRE where the quills are folded over two lines of threads, creating a pattern of triangles. Quills were further plaited or woven on a simple bow loom. The warp of sinews was attached to the ends of a bent branch which held it under tension. The quill strips, occupying the spaces between the warp threads, were folded over the weft which was passed alternately above and below the warp. When pushed well together, the warp and weft were entirely covered by the quills.

From the seventeenth century onwards, Indian art and design was greatly influenced by the European objects which reached the Great Lakes through trade, and whose styles were those of contemporary European art and fashion. Particularly important were new materials such as cloth, beads, ribbon and silver brooches. With the arrival of settlers from Europe, the Indians also became exposed to European folk art. The Indian women showed great artistic skill and imagination, as well as business acumen, in using these materials.

Before the arrival of European trade goods, beads were mainly made of shell. The introduction of glass beads made a very great impact on Indian decorative art, gradually replacing all other techniques, especially where cloth fabrics replaced skins. Many of the patterns found in quill work were later translated into bead work.

Shell beads — known as wampum — survived for certain particular purposes in the Great Lakes area. Among the Indians in the north and north-east, pictographical and ideographical symbols were used to convey and record ideas and events. Among the Iroquois and neighbouring nations belts of wampum beads were used to convey messages and to confirm treaties with the Europeans and with other nations. Wampum beads were chosen for these uses because they already had ritual and ceremonial associations. The beads were made from the shell of the clam *Mercenaria mercenaria L*, the purple beads from the lip of the shell, the white from other parts of this shell or from the columellae of conches. The shells were woven on a warp of leather thongs or fibre cords. The method is illustrated at **38**. The significance of the designs on the belts illustrated on this page can only be guessed at in very general terms: the figures holding hands symbolized friendship, the parallel lines trails or paths and the outlined crosses territories or nations. Diagonals are thought to have referred to allies or support given to a treaty or message by a third party.

Glass beads were woven into belts, sashes, garters etc. on a simple loom using similar techniques to that illustrated at **38** BOTTOM (**42** − **43**). Beads were also stitched on panels used for appliqué. The technique used was spot or overlay stitching, that is, a line of threaded beads was secured at intervals with a stitch into the base material by a second thread. With the 'lazy stitch' the beads were threaded on a single thread which was stitched to the base at intervals. A third method runs a second thread at right angles to the lines of the threaded beads, securing them with a spot stitch. The latter methods were particularly used by the Plains Indians. These techniques allowed both outlines and solid shapes to be produced with great freedom of choice of colours and shapes (**47** − **49**).

Belts, garters, burden straps and sashes were produced in various finger-weaving techniques including weft twining on stretched warps and multiple-strand braiding (**40, 41**). Mats were woven from cedar bark and reeds (**36** CENTRE). Particularly intricate methods of twining were used to make rectangular bags, each woven in one seamless piece and often using several techniques of twining and braiding to create decorative effects. The two-colour designs on the central panels were achieved by using two sets of warps in alternate pairs of different colours. **37** BOTTOM RIGHT illustrates how each pair of warps divides in one

row of weft twining and joins the nearest warp thread in the adjoining pair of the same colour. In the next row the warp threads rejoin their original partners. The warp threads of one colour thus lie on the outside while the threads of the other colour pass behind. Where the design demands a change of colour, the position is reversed. This technique produces a texture of small diamond shapes bisected by the weft. The designs must of necessity be simple (**36** BOTTOM, **37** BOTTOM).

Fine embroidery in European styles, using silks and other imported yarns, was taught to Indian girls in the convents and mission schools established by the Ursuline nuns in French Canada in the seventeenth century. These skills were adapted to the use of moosehair. From the eighteenth century onwards Europeans valued souvenirs in moosehair and quill work in designs influenced by contemporary European styles, adapted by the Indian women to their own taste (**46**).

Like quills, moosehair was dyed with vegetable or commercial dyes. The embroidery was carried out by taking a few hairs and sewing them to the leather with a diagonal stitch using a thread of sinew. Before the next diagonal stitch was pulled tight, the hairs were given a twist, producing a bead-like effect between stitches. New hairs were added by splicing the ends of the old and new hairs and securing with a stitch. If passed back and forth between two parallel lines of stitches, a zig-zag line could be produced (**46** BOTTOM).

False moosehair embroidery was applied in weaving: the hairs were wrapped round the weft as it appears on the front of the work, passing from one weft thread to another along the surface of the weave.

Silk ribbons were very fashionable in eighteenth-century Europe, being produced in large silk mills in France and also imported from the Orient. By 1797 the French Revolution made such aristocratic trappings redundant and suppliers found themselves with much unwanted stock. The ribbons were exported and used in the fur trade with the Indians in the North-east, where the ribbon appliqué technique developed most successfully.

The Indian women used the ribbons to produce panels of multi-coloured appliqué which were stitched along the seams or round the hem of garments of dark blue, black or red trade cloth. Some ribbons were folded concertina-fashion and a template representing half of the symmetrical pattern were placed on the folds and cut out. In this way many identical pattern units were produced. These were sewn by cross- or herringbone-stitch to another ribbon which formed the background. Several such ribbons were sewn together and backed by light cotton. The complete panel was finally stitched to the garment (**50 − 51**). The technique has remained in use today, silk ribbon being replaced in the twentieth century by rayon, taffeta, satin and nylon materials.

The traders offered silver brooches in exchange for furs as early as the middle of the eighteenth century. Large quantities of these ornaments were produced especially for the Indian trade in England and later in America by English and Scottish silversmiths in their own contemporary or traditional styles. With the decline of the fur trade the supply of silver brooches diminished and the Indians took up the craft, continuing to produce designs with which they had become familiar, using the techniques of stamping and engraving to make open-work brooches (**35**).

By the early nineteenth century a cheaper material known as German silver — an alloy of copper, zinc and nickel — was increasingly used. This material was also used in the metalwork of the Plains Indians who received these skills from the Indians and traders to the east.

The Plains

The Indians of the central plains, who lived from cultivation, fishing, gathering and the seasonal hunting of the buffalo, changed their lifestyle drastically after the introduction of the horse into the South-west by the Spaniards in the sixteenth century. The mounted Indian, hunting buffalo, wearing feather head-dress and bead-embroidered skin clothing, was to become the epitome of the image of the Indian in the popular imagination. In the nineteenth century a growing demand for leather by the industries of the east and easy transport down the Missouri river made the Plains Indians eager for trade. The goods they received in return for their hides were used to produce the colourful display of their dress and the trappings for their horses. They also received guns, used not only for hunting but for the warfare between nations.

The nomadic lifestyle of the Plains Indians did not favour the production of large works of art: thus their artistic skills were concentrated on the covers of their tents, the trappings of their horses and the clothes they wore — painted skin robes and shirts, bead-embroidered dresses for the women, leggings and moccasins (**55** BOTTOM RIGHT, **58** — **59**). Elaborate hair arrangements included 'roaches' of animal hair and feathers, held in place by 'roach-spreaders', delicately decorated though virtually invisible when in use (**62**). Even their bodies were decorated with paint.

The cloaks of buffalo hides worn by the Plains Indians demonstrate a technique of skin painting which was similar to that used by tribes elsewhere in the east and north, although the style of decoration varied. The tanned skin or rawhide was first treated with a clear sizing of a glue-like substance. This served to preserve the original colour of the hide, and areas so treated would retain a lighter colour as the surrounding hide became dirty when used. The outline of the design was scratched into the surface and the colour applied with a stylus of bone or wood. The colours available from indigenous sources were of mineral or vegetable origins, but pigment of a more varied range became available through trade.

The painted designs fall into distinctive groups. Figurative designs recording events such as battles can be regarded as pictographs (**59** BOTTOM RIGHT for example). Typically, the figures in these scenes are placed in relation to each other in order to tell a story and there is no attempt to achieve balanced compositions. The shield cover at **59** BOTTOM LEFT shows another type of design, illustrating a scene from the dream world, which was so important in the spiritual beliefs of the Plains Indians.

Both types of design were painted by men, while the designs painted by women were mainly highly conventionalized and stylized symbolic representations or purely decorative patterns. These were applied to

cloaks but also to the rawhide containers in which food and other possessions were carried (**56 − 58, 59** TOP).

The vigorous and colourful culture of the Plains Indians came to an abrupt halt when the buffalo herds were finally exhausted in the 1870s.

The North-west

The area known as the North-west Coast is a narrow strip of land along the Pacific Ocean reaching from Yakutat Bay in Alaska to Washington State. On the landward side the area is bordered by the steep Coastal Ranges. The Alaska current sweeps along the coast producing a damp and relatively mild climate and supporting a wide variety of fish and sea mammals. The rugged country is covered by rain-forests of firs and cedars. Contacts with the dry and much colder Plateau behind the mountain ranges were only possible along a few rivers.

This isolated and well-favoured environment offered abundant fishing and hunting and allowed the people living here to develop a highly structured and organized society in which art came to play an important part. The social system was based on clans and stressed family lineages. This was expressed in the heraldic nature of the art. Clans and families were symbolized by animal crests which form the main motifs in the art. The wealth of the society made it possible for professional artists to be supported.

The main material was wood, carved and painted, and when other materials like bone, antler, ivory or metal were used, the techniques and decoration conformed to the rigid rules of design which applied to work in wood. The highly decorative nature of the designs sometimes obscures the heraldic significance and symbolism of the motifs.

Some basic principles of animal representation can be distinguished. The animal may be shown with a recognizable outline, but with the addition of vital internal organs − the x-ray feature also found in other arts of the north (**66 − 69**). In other designs the anatomical relationships between the parts of the body are to some extent retained, but the animal may be split and its parts rearranged to fill a given space (**75**). In many designs, however, such relationships are totally ignored and the decorated space entirely filled with animal parts and unrelated elements − often in the form of little faces − which make the identification of the main motif difficult or impossible (**71, 72, 74**).

These designs are not random, but follow rules which can be identified in some cases. Bill Holm (*Northwest Coast Art, An Analysis of Form*, 1965) has analysed some of these ornaments and formulated some rules which apply to many of these designs. The analysis of the head of a salmon trout illustrated here (**70**) is taken from his work. The framework of shapes ('formlines') which make up these designs was produced by templates in the shape of the spaces they enclose.

This type of design, on whatever material, was always the work of male artists. Women used geometrical designs in basketry and weaving. The Chilkat blanket is exceptional in that it was woven by women on the basis of wooden pattern-boards made by men (**72**).

Among the many objects collected by Captain Cook in 1778 are some cloaks of cedar bark fibre in twined weaving. Some of these were plain or

had a border of geometrical patterns along their curved edges; others had painted heraldic designs (**67**). It was not long after the first European contacts that the remarkable 'Chilkat dancing blankets' began to emerge. These were not blankets but cloaks, worn around the shoulders on ceremonial occasions and fastened in front with leather thongs.

A very close relationship exists between the techniques of the twined basketry produced in this area and the tapestry twining of the Chilkat blankets. It is clear that the techniques were specially developed and adapted to produce the painted and carved motifs. The blankets were designed and produced to commission by professional weavers. The crest figure which occupies the centre of the design is now often difficult to identify, although an attempt is made to isolate this figure, an eagle, in the design of the blanket illustrated at **72**. The warp was made of mountain goat wool, spun together with the inner bark of the cedar tree into a two-ply Z-twist yard. The weft yarns often vary in weight in the same blanket and commercial four-ply yarns were often used in later examples. The white wool yarn was originally dyed with native and later with commercial dyes. The colours are black, yellow and shades of green or blue-green.

The loom was upright, the warp hanging freely from the single beam. The main body of the weaving is a two-strand twining over alternate warp pairs, each succeeding row splitting the warp strands in the row above (**73 A**). The joins between two colours were achieved by using variations of two basic methods (**73 B, C**) and were often covered by braids on the front of the blanket. Disregarding usual weaving conventions, these braids (**73 D**), which outline differently coloured shapes in the design, are twined into either the warp or the weft (**73 E, F**).

There is no real distinction between basketry and other common domestic techniques of weaving, plaiting and braiding. The main differences lie in the rigidity or flexibility of the fabrics produced.

Geometrical designs developed naturally from the basket-weaving techniques. The twined baskets in this area reached high technical and artistic standards (**84 − 87**). Representational designs are not common in this medium, but there are splendid scenes of whale hunts on the chieftains' basket hats made in a twined weave of spruce root and cedar bark with a double shell joined at the brim (**80 − 81**).

Apart from brief visits by Russian and Spanish explorers, the first European to arrive was Captain James Cook in 1778. His expedition brought back a collection of artefacts, now in the British Museum, some of which are illustrated here (**67**, **77** TOP LEFT, **80**, **81**). These and other objects collected by explorers in the eighteenth and nineteenth centuries show that the art of the North-west Coast was at that time fully developed. During the nineteenth century the increased contact and trade greatly stimulated artistic production as traders and collectors were eager to buy.

In time, however, with the deliberate suppression of the traditional lifestyle of the Indians and the increase in the number of settlers and the creation of towns and cities the practice of art declined. More recently Indian artists have emerged who are able to produce a new art on the foundation of the old (**69** BOTTOM).

The West and South-west

The dominant geographical features of the West and South-west are the coastal areas of California, the mountain ranges of the Sierra Nevada and the Rocky Mountains, enclosing the deserts of the Great Basin. To the south the Rockies level out into a plateau and the deserts of southern Arizona. In this area conditions for human survival varied greatly and highly specialized modes of subsistence evolved based on gathering and hunting.

The long coastline and fertile valleys of California supported a large population. The tribes living here depended for their food on acorns which they made into a mush. They developed particularly impressive skills in making the baskets used for the collection and preparation of this food.

Fragments of basketry several thousand years old have been found in archaeological excavations in North America. All the basic techniques of basket making present when the Europeans first began to collect examples of native art are found in the archaeological evidence. Only one technique, wood splint basketry, may have been introduced into the North-east through contact with European settlers.

Baskets were used for a large variety of purposes. They could be made watertight by a densely woven texture or by the application of substances such as gum, resin and even mineral asphalt. They were used for cooking — hot stones were dropped into baskets filled with food and water — for storage, traps and clothing. The material was always and everywhere close to hand.

There are two distinct types of technique in basketry: weaving on a warp foundation and sewing on a coiled foundation. Both types were produced in this area. The diagrams at 82 TOP LEFT and 83 TOP illustrate the principle of twined weaving. The weft elements are worked in pairs or even in threes. In passing from warp to warp the weft strands are twisted in half turns on each other. In plain twined work the elements pass regularly over and under the warp. The patterns on baskets produced by this method are usually arranged in horizontal borders. In twilled twined work the weft element passes over two or more warps. This method allows the possibility of more varied patterns. Many baskets are further decorated by introducing coloured elements which are not part of the actual structure such as overlay, false embroidery and even feathers. These materials, coloured grasses for instance, are wrapped round the weft strands as they appear on the outside in the course of the weaving. The rims were finished off in many different ways, one of which is illustrated at 82 TOP RIGHT.

In the south of this area and in the South-west most baskets were made by coiling. The foundations of coiled baskets may be single, double or treble rods, splints, bundles of grass etc. As the vessel is built up by coiling the foundation round and round in a spiral, each turn is sewn to the one below with stitches which may enclose the foundation completely. Two varieties of this technique are shown at 90.

A particular type of coiled basketry was developed on the Plateau and on the North-west Coast. This is known as imbricated basketry. The foundations of these baskets are bundles of cedar and spruce root, sewn

together with root fibres. At the same time a strip of coloured bark or grass is laid down on the outside of the foundation and caught under a stitch. Before the next stitch the strip is folded over to cover the previous stitch in a kind of knife pleating (**92** TOP). The sewing is therefore completely hidden, and the introduction of differently coloured pleated strips produces the ornament on the outside of the basket.

In the extreme South-west, Middle American influences gradually introduced the cultivation of maize, squash (pumpkin) and beans by irrigation farming. The same influences introduced pottery and weaving. The Indians lived in communal villages (*pueblos*) of vast honeycombs of flat-topped dwellings, now mainly centred in Southern Arizona and New Mexico, but originally more widely distributed in the South-west. Although their lifestyle and economy were similar, the people who lived in the *pueblos* showed many regional variations in language and architecture. Their distinctive pottery has been recovered by excavation at many large settlement sites.

The methods of making pottery were however similar throughout the area and have remained unchanged today. The clay was tempered with various substances, such as crushed shell or potsherds, volcanic ash or sand. This served to produce a suitable plasticity and texture for working and assured tolerance to sufficiently high temperatures during firing to produce a hard and serviceable fabric.

Vessels were raised by coiling, the soft clay was rolled out into long sections which were worked together, either as rings laid one on top of another, or as a continuous spiral. The surface was smoothed out with a simple scraper. The skill of the potter is demonstrated by the absence of any visible joins between the coils and by the thinness of the fabric. Before the body had completely dried, the surface was often burnished with a hard, smooth object (such as a stone) or covered by a slip.

The body colour would vary according to the local materials. Slips could be of a natural white kaolinitic clay or of iron-rich clays producing red and orange colours. Black vessels are the result of reduced firing. Decorations were carried out before firing in a black paint of vegetable origin. Other colours such as red and orange were, like the slips, produced from iron-rich substances.

The firing was carried out in clamps where the pots were stacked and covered with slow-burning fuels like dung. This method of firing demands considerable skill if the pots are not to crack, warp or discolour, and such blemishes are not infrequently seen. The fine bowls of the Mimbres, for instance, are often distorted into oval or irregular shapes, although their decoration clearly shows that they were originally perfectly circular (**6 − 13**).

Another common feature is the use of black paint on a white slip. Decorations are often abstract, and it is thought that some of the linear patterns are based on patterns on baskets, which were the most common containers before pottery was widely used. In time other colours were introduced, predominantly red. Abstract designs often use the device of negative painting (**5, 14 − 18**). A paint which fused into a glaze on firing was used on certain types of pottery.

It is typical of the pottery of the South-west that the decoration is largely unrelated to the form of the vessel. The painted patterns can exist

independently of the shape on which they are applied. In extreme cases the decoration flies in the face of the form as in some nineteenth-century Acoma pots (**19**, **21**). This is also true to an extent of the remarkable figurative designs of the Mimbres. The rounded bowls, while beautifully balanced in their designs, use methods of masking the round shape to suit motifs contained in irregular fields (**6** − **13**).

The Spanish presence in the area from the sixteenth century onwards was more successfully resisted by these Pueblo Indians, who, being farmers, were not as dispersed as many other North American Indian nations. Their descendants still live there and retain much of their own culture. In this century talented potters have emerged who, while basing their art on traditional methods and designs, produce ware of high artistic standards (**21** TOP, **25** − **27**).

Twined textiles are known from the prehistoric period in the Southwest and they continued to be made in a specialised form, as fur and feathers were twined in vegetable fibre warps to make blankets and cloaks.

The true loom, with a mechanical device for making sheds was introduced from Middle America in the eighth century at the same time as the cultivation of cotton. A wide vertical loom was used as well as a small belt loom. Although plain and twill weave were most common, other techniques like brocading, weft-float pattern weaves etc. were also known.

The Spaniards introduced sheep into the Pueblo area in the sixteenth century. The Navajo, who had recently arrived in the area and had abandoned their nomadic lifestyle for farming, also adopted Pueblo weaving techniques based on wool, and developed exceptional skills as weavers. With the opening of the Santa Fe trail in 1822 and the ensuing expansion of trade, the blankets woven by the Navajo and used as saddle blankets, dresses, cloaks and bedding, became important for trade with other tribes and were highly valued.

The Navajo produced the classical wide Pueblo blanket in designs of five stripes, each further subdivided, with nine or twelve blocks of contrasting colour and design. The colours were the natural shades of the wool from creamy white to dark brown, as well as blue, red and occasionally small amounts of green and yellow (**28** − **29**).

The Navajo also adopted the weaving of *serape*, or shawls, from the Spanish and began to use the tapestry weaving technique. The patterns on these often took the form of diamonds and triangles combined with stripes (**30**). Commercial yarns introduced new colours.

Towards the end of the nineteenth century the availability of aniline and other synthetic dyes produced an explosion of strong colours which, with the use of patterns dissolved into small units with serrated edges and other devices, produced optical effects which gave these designs the name 'eye-dazzlers' (**31** TOP). At the same time the weaving of blankets, for which there was now less tribal demand, was replaced by the production of heavier rugs for the commercial market. Pictorial rugs were decorated with motifs ranging from cattle to trains (**31** BOTTOM) and from letters to the American flag. Designs with frames surrounding central motifs emerged, although traditional stripes were still common. The colours became more subdued and more suitable for floor coverings.

Around the turn of the century a new style became popular, featuring large figures in bold colours (**32**). In the twentieth century Navajo weaving was controlled by traders who produced catalogues from which rugs could be ordered, and this greatly influenced the patterns produced. Some of the traders preferred the style of the classical blanket, while for others oriental and other motifs had more fashion appeal. The weavers obliged with what were on the whole well-balanced and attractive versions of what was asked of them (**33** BOTTOM).

Pictorial designs developed in a new direction in the early twentieth century; motifs taken from the sand paintings created during secret ceremonies were produced on woven rugs. These became some of the most popular designs (**33** TOP). More recently there has been a revival of older designs, a trend which, as we have seen, is common in arts and crafts among the North American Indians.

The Navajo learnt silver-smithing from the Mexicans around the middle of the nineteenth century and it became one of their most important crafts. Their techniques include soldering and casting with stamped, engraved and embossed decoration. Bridles, buttons and beads were adopted from Mexican work, while other forms were derived from the silver ornaments produced by the Plains Indians, who in turn had received their designs from the Great Lakes and ultimately from Europe. Much of the ornament is based on the leaves and flowers of the maize plant and squash (pumpkin) (**34**). Inlays of turquoise, shell and other material are widely used.

Work in silver is now widespread in the South-west and silversmiths of various tribes have developed distinctive styles producing large quantities for the commercial market ranging in quality from mediocre tourist souvenirs to works of art.

With their ability to adopt and adapt customs and crafts from other cultures, the Navajo have proved to be the most successful of the North American Indian nations.

Looking through these pages of patterns and designs based on the art of the North American Indians from prehistoric to modern times, the art emerges as both vigorous and durable. The limitations imposed by the materials and the prescribed patterns and motifs have disciplined the imagination of the individual craftsman in a positive way, resulting in an art which is remarkably distinctive and yet capable of growth. There is much to learn from the infinite variety created from its simple themes.

Notes on the designs

1 Cut-out repoussé copper ornament. Height 28cm. Spiro Mound, Oklahoma. *Ohio State Museum*. 14th – 18th centuries.

2 TOP Extended and reconstructed design engraved on a conch shell fashioned into a cup. The motif consists of entwined snakes with bird-like heads. The shell is of the genus *Busycon*. Spiro Mound, Oklahoma. *University of Arkansas Museum*. BELOW LEFT Shell pendant with an engraved design representing a chunkee player. This game – which may have been a ritual – was played by most south-eastern groups. One player rolls a stone disc on the ground while the opponents, throwing lances, aim to hit it. Diameter 12.5cm. Eddyville, Kentucky. *US National Museum of Natural History, Smithsonian Institution*, Washington DC. RIGHT Stone palette with an engraved design of rattlesnakes with plumed heads. Diameter 21.9cm. Moundville, Alabama. *Ohio Historical Society*, Columbus, Ohio. 13th – 18th centuries.

3 – 4 Pottery with engraved and painted designs from Arkansas. Added sculptural features represent mythical creatures like the cat serpent or human forms. The length of the vessel at **3** TOP is 32cm, the heights of the vessels at **3** BOTTOM and **4** vary between 20 and 30cm. 8th – 18th centuries.

5 Pot with a painted design in red on a buff slip. Height 30cm. Hohokam. Arizona. *Denver Art Museum*, Colorado. BELOW Design from a similar vessel. 11th century.

6 – 13 The designs on these pages are taken from pottery bowls painted on the inside in black on a white slip. In a few instances (**11** BOTTOM LEFT and **12** BOTTOM LEFT) a second colour – red – is used, shown here as a screen. The bowls are *c.* 25cm in diameter and 10 – 12cm deep, the outline is gently curved. Mimbres. New Mexico and Arizona. 9th – 12th centuries. These bowls are in the following collections: *The Art Institute of Chicago*, Chicago, Illinois, **9** BOTTOM LEFT; *The Arizona State Museum*, University of Arizona, Tucson, **10** BOTTOM RIGHT; *Historical Museum and Institute of Western Colorado*, Grand Junction, **12** TOP; *The Maxwell Museum of Anthropology*, University of New Mexico, Albuquerque, **9** BOTTOM RIGHT, **11** TOP; *The Mimbres Foundation*, Los Angeles, California, **10** BOTTOM RIGHT; *Museum of New Mexico*, Santa Fe, **6** BOTTOM RIGHT; *Museum of Northern Arizona*, Flagstaff, **7** TOP, **13** BOTTOM LEFT; *Peabody Museum*, Harvard University, Cambridge, Massachusetts, **8** TOP, **11** BOTTOM RIGHT; *The Taylor Museum of Colorado Springs Fine Art Center*, Colorado Springs, **8** BOTTOM LEFT; *University of Colorado Museum*, Boulder, **6** BOTTOM LEFT, **12** BOTTOM RIGHT, **13** BOTTOM RIGHT; *US National Museum of Natural History, Smithsonian Institution*, Washington DC, **10** TOP; *Western New Mexico University Museum*, Silver City, **11** BOTTOM LEFT, **13** TOP LEFT; *Private*

Collections, **6** TOP, **7** BOTTOM LEFT and RIGHT, **8** BOTTOM RIGHT, **9** TOP, **12** BOTTOM LEFT.

14 – 15 The border patterns on these pages are taken from pottery, painted in black and red on a light background, excavated at Casas Grandes, Chihuahua, Mexico. 12th – 13th centuries. The culture represented on this site, a former Middle American outpost on the borders of the South-west, provides a link between these areas. The macaws portrayed in the painted patterns were bred here and exported to the Pueblos where they became part of religious ceremonies.

16 – 17 Pottery from New Mexico painted in black on a white slip. These vessels are 40 – 50cm high. The patterns BELOW are taken from similar vessels. 11th – 13th century.

18 The pattern on the pot TOP is painted in black on a white slip. Height *c.* 40cm. 12 – 13th centuries. The patterns BELOW are taken from similar vessels. 11th – 13th century.

19 – 21 Designs on painted water jars by the Acoma Pueblo, New Mexico, showing the range of their traditional styles. The colours of the designs at **19** and **20** are black and red on a white slip, at **21** black, red and orange (red and orange are here represented by screens). The height of the jars varies between 15 and 30cm. 19th century, except for the vessel at **21** TOP which was made by Lucy M. Lewis in 1969 and demonstrates the modern revival of traditional designs.

22 TOP Water jar painted in black and red on a white slip. The heart and windpipe of the deer are painted red. Zuni Pueblo. New Mexico. *British Museum*. BELOW The extended design from a similar vessel. 19th century.

23 The painted designs TOP are taken from a 19th-century water jar while the design BELOW was painted in 1976 by Dextra Quotskuyva Nampeyo.

24 Designs painted on the inside of shallow pottery bowls. TOP Black and white on a red base. Diameter 25.5cm. Four-mile polychrome. *Private collection*. BELOW LEFT Black on a yellow base. Diameter 30.5cm. Pueblo, Jeddito ware. *Peabody Museum*, Harvard University, Cambridge, Massachusetts. BELOW RIGHT Brown on an orange base. Diameter 25.1cm. Sikyati. *University of Colorado Museum*, Boulder, Colorado. Arizona, 14th – 17th centuries.

25 Designs painted on the inside of shallow pottery bowls. TOP Black on a white slip. Diameter 28.5cm. Hopi. Sadie Adams 1948. *Denver Art Museum*, Colorado, BELOW LEFT Diameter 18cm. Hopi. *British Museum*. BELOW RIGHT Diameter 27cm. Modern Pueblo. *British Museum*. Arizona, 20th century.

26 Painted pottery designs by Maria and Julian Martinez. San Ildefonso Pueblo. New Mexico. 20th century. TOP Height 32.3cm; CENTRE diameter 38cm. *Denver Art Museum*, Colorado. BOTTOM Design of stylized butterflies. *Private collection.*

27 TOP Design painted in black and red on a yellow base from pottery by Dextra Quotskuyva Nampeyo, 1976. BELOW Painted borders from 20th century pottery. Zia and Santo Domingo Pueblo.

28 – **29** Blankets woven by the Navajo of New Mexico and Arizona. Second half of the 19th century. **28** TOP 184.5 x 137cm. *Private collection*; BELOW 180.3 x 144.8cm *Natural History Museum of Los Angeles County*, Los Angeles, California. **29** TOP 173 x 132cm. *Denver Art Museum*, Colorado; BELOW 139.7 x 118.1cm. *Private collection.*

30 – **31** Serape and blankets woven by the Navajo of New Mexico and Arizona. Second half of the 19th century. **30** TOP 177.8 x 95.3cm. *The University Museum*, University of Pennsylvania; BELOW 174 x 127cm. *Southwest Museum*, Los Angeles, California. **31** TOP 188 x 129.5cm. *Private collection*; BELOW detail from a pictorial blanket. *Natural History Museum of Los Angeles County*, Los Angeles, California.

32 – **33** Blankets woven by the Navajo of New Mexico and Arizona. 20th century. **32** in *Private Collections.* **33** TOP 183 x 160cm. *Denver Art Museum*, Colorado; BELOW *Heard Museum*, Phoenix, Arizona.

34 Navajo silver work. TOP Details of bridle mounts. *Denver Art Museum*, Colorado. c. 1900. CENTRE Cast brooch. *Private collection.* c. 1930; CENTRE LEFT and RIGHT details from 'squash blossom' necklaces of silver inlaid with turquoise. BOTTOM Bow guards of stamped, embossed silver inlaid with turquoise. *Fred Harvey Fine Arts Collection, Heard Museum*, Phoenix, Arizona. 20th century.

35 TOP and CENTRE LEFT Ornaments in German silver — an alloy of copper, zinc and nickel. Shoshoni. Wyoming. c. 1860-80. The rest are all silver brooches made by the Iroquois of New York in the late 18th and early 19th centuries. *Denver Art Museum*, Colorado.

36 – **37** Designs from the art of the Woodlands Indians of the Great Lakes area. For a more detailed description of these motifs and techniques see p.11 ff.

38 Wampum belts (see p. 13):: TOP *The Historical Society of Pennsylvania*; BELOW *The Museum of the American Indian, Heye Foundation*, New York. Length approximately 60 – 70cm. 19th century. The diagram illustrates the method of weaving the wampum beads on a warp of leather or fibre cord.

39 – **51** Designs from the art of the Woodlands Indians of the Great Lakes area. For a more detailed description of these motifs and techniques see p. 11 ff.

52 Naskapi summer hunting coat of caribou skin with details of the painted designs. *British Museum. c.*1840.

53 Painted designs and decorative rosettes in quill work from Métis skin coats. *British Museum.* 19th century.

54 – **55** The designs and techniques of the moccasins illustrated here are discussed in more detail on p. 11 ff.

56 – **57** Rawhide containers, known as parfleche. Approximate size 60 x 30cm. The designs are painted except **57** BOTTOM RIGHT where it is incised. Plains Indians. 18th and early 19th centuries. *Chandler-Pohrt Collection, Great Lakes Indian Museum*, Cross Village, Michigan, **57** BOTTOM LEFT; *Denver Art Museum*, Colorado, **56** TOP RIGHT, BOTTOM LEFT and RIGHT, **57** TOP LEFT, BOTTOM RIGHT; *Private collection*, **56** TOP LEFT. **57** TOP RIGHT is taken from pl.81 of the Atlas included in Maximilian, Price of Wied, *Travels in the Interior of North America*, reprinted in *Early Western Travels*, 1906.

58 Painted buffalo hides. TOP 185 × 135 cm. *Linden Museum*, Stuttgart, West Germany. Collected by Prince Maximilian of Wied during his travels up the Missouri River in 1833. BELOW *US National Museum of Natural History, The Smithsonian Institution*, Washington DC, 19th century.

59 TOP Painted buffalo hide. Sioux. *US National Museum of Natural History, The Smithsonian Institution*, Washington DC. BOTTOM LEFT Painted shield cover. Diameter 50.5cm. Kiowa. Oklahoma. *US National Museum of Natural History, The Smithsonian Institution*, Washington DC. BOTTOM RIGHT Painted shield cover. Diameter 56.5cm. Sioux. South Dakota. *The Museum of the American Indian, Heye Foundation*, New York. 19th century.

60 Prehistoric pipe bowls carved in stone. TOP Tennessee. Length 15.2cm. *The Museum of the American Indian, Heye Foundation*, New York. CENTRE LEFT Hopewell culture. Tremper Mound, Ohio. Length 9.8cm. *Ohio State Museum*, Columbus; CENTRE RIGHT Hopewell culture. Length 16.1cm. *Ohio Historical Society*, Columbus. BOTTOM LEFT Ohio. Length 27cm. *Ohio State Museum*; BOTTOM RIGHT Illinois. Early Mississippian Period. Length 17.4cm. *Peabody Museum of Natural History*, Yale University, New Haven, Connecticut. 100 BC – 1200 AD.

61 TOP Ceremonial pipe. Crow. Montana. Length 86cm. c. 1850. *Denver Art Museum*, Colorado. CENTRE Pipe bowl of catlinite with inlay of lead. Length 25.1cm. Eastern Sioux. Minnesota. c. 1880. *Chandler-Pohrt Collection, Great Lakes Indian Museum*, Cross Village, Michigan. BOTTOM Pipe bowl carved in stone. Length 25.2cm. Cheyenne. Wyoming. Mid-19th century. *Denver Art Museum.*

62 Roach spreaders of elk antler. The lengths vary between 15 and 22cm. TOP from LEFT to RIGHT: Fox.

Private collection; Sauk and Fox. *Milwaukee Public Museum*, Wisconsin; Chippewa. *Private collection*; Sante Sioux. *The Brooklyn Museum*, New York. BOTTOM from LEFT to RIGHT: Pawnee. *Denver Art Museum*, Colorado; Sauk and Fox. *Peabody Museum*, Harvard University, Cambridge, Massachusetts; Iowa. *Private collection*; Fox. *Private collection*. 19th – 20th centuries.

63 LEFT TOP Antler comb, Susquehannock; BOTTOM antler comb. Seneca Iroquois. Height 10cm. 17th century. *The Rochester Museum and Science Center*, New York. TOP CENTRE Drumstick of antler. Length 32cm. Ojibwa. 19th century. *US National Museum of Natural History, Smithsonian Institution*, Washington DC; RIGHT antler club. Length 63.5cm. Tlingit. *c.* 1875. *The University Museum*, Philadelphia.

64 – 65 Carved and painted masks. **64** TOP LEFT *Peabody Museum*, Salem, Massachusetts; RIGHT *British Museum*. BOTTOM LEFT *Field Museum of Natural History*, Chicago, Illinois; RIGHT *Denver Art Museum*, Colorado. **65** TOP LEFT and BOTTOM RIGHT *British Museum*; TOP RIGHT *Denver Art Museum*, Colorado. BOTTOM LEFT *Horniman Museum*, London.

66 This screen was originally part of the Grizzly Bear House at Wrangell Village, Alaska. It stood parallel to the back wall and separated the chief's apartment from the rest of the house. 4.57 x 2.74m. Tlingit. *c.* 1840. *Denver Art Museum*, Colorado.

67 These designs are taken from cloaks in the *British Museum*. They are discussed on p. 16.

68 – 69 68 TOP *British Museum*; BELOW *Washington State Museum*. **69** TOP *Bernisches Historisches Museum*, Bern, Switzerland; BOTTOM this blanket was made in 1974 by Shona Hah of the Lelooska family. 183 x 244cm. Owned by the artist. These designs are discussed on p. 16.

70 This analysis is based on Bill Holm, *Northwest Coast Art, An Analysis of Form*, 1965, fig.21.

71 TOP Painted design on a wooden box. 78 x 47cm. BELOW Painted and carved design from a wooden box. 38 x 18cm, Haida. The North-west Coast. Mid-19th century. *British Museum*.

72 – 73 Chilkat blanket. Width 160cm. *British Museum*. The designs and techniques of these blankets are discussed on p. 16 ff. The diagrams at **73** are based on Cheryl Samuel, *The Chilkat Dancing Blanket*, 1982.

74 *Portland Art Museum*, Oregon.

75 *The University Museum*, Philadelphia, Pennsylvania. The 'copper' was a ceremonial object made in the shape of a shield, some 60-70cm high, from sheet copper and decorated with painted or etched designs of the owner's crest.

76 LEFT Knife finials in the shape of bears' heads. TOP Carved in wood. *Peabody Museum*, Harvard University, Cambridge, Massachusetts; BELOW engraved copper. *Denver Art Museum*, Colorado. RIGHT Steel knives; the handles are bound with leather and twine, the eyes of the finials are inlaid with abalone shell. Length approximately 40cm. LEFT *US National Museum of Natural History, The Smithsonian Institution*, Washington DC. RIGHT *British Museum*. Tlingit. The North-west Coast, 19th century.

77 TOP LEFT Whalebone club; the blade is inlaid with abalone shell, the handle is bound with twined hair and fibre cord. The carved finial is the head of a Thunderbird with a bird-shaped head-dress. Length 57.5cm. Nootka. 18th century. *British Museum*. TOP CENTRE Whalebone knife. Length 42cm. *Cranbrook Institute of Sciences*, Bloomfield Hills, Michigan. TOP RIGHT The head of a rattle carved in wood in the shape of a bear's head. Haida. 19th century. *British Museum*. BOTTOM LEFT Shaman's charm in the form of a killer whale carved from antler. The natural curve of the antler with a branching tine has been incorporated in the design, Length 12.5cm. *Southwest Museum*, Los Angeles, California. BOTTOM RIGHT Spindle whorl of wood. Diameter 18cm. Salish. Vancouver Island. *The Brooklyn Museum*, New York. The North-west Coast.

78 – 79 78 TOP and BOTTOM RIGHT, **79** Spindle whorls carved in maple wood. Diameter approximately 20cm. *British Museum*, **79** TOP RIGHT; *The Museum of the American Indian, Heye Foundation* New York, **79** BOTTOM LEFT; *Portland Art Museum*, Oregon, **79** TOP LEFT; *Provincial Museum*, Victoria, British Columbia. **78** BOTTOM LEFT Head of a rattle carved in horn. *Museum voor Land- en Volkenkunde*, Rotterdam, Netherlands. Coast Salish. British Columbia. 19th century.

80 – 81 Basketry hats in twined weaving. Extended drawings of the complete designs after Martin Langdon. Vancouver Island. 18th century. *British Museum*. See also p. 17.

82 – 87 The basketry techniques illustrated here are described in more detail on p. 18.

88 The basketry techniques illustrated here are described on p. 11.

89 Wickerwork basket tray. Diameter 37.5cm. Hopi. Arizona. 1934. *Denver Art Museum*, Colorado.

90 – 91 The basketry technique illustrated here is described on p. 18.

92 – 93 The basketry technique illustrated here is described on p. 18. The examples at **93** are in the *British Museum*.

94 Baskets from the North-west Coast. TOP height 33cm. Kliketat. Oregon; BOTTOM LEFT height 35cm. Cowlitz. Washington; BOTTOM RIGHT height 25cm. Kliketat. Oregon. *British Museum*.

95 TOP height 29cm. Modoc. Oregon. *British Museum*. BELOW basket patterns of the Quinault Indians, Washington.

96 – 99 The patterns illustrated on these pages are taken from shallow basketry bowls or trays made in

coiled sewing (see p. 18). They represent types which are still being made today. Many of the illustrated examples are taken from O. T. Mason, 'Aboriginal American Basketry', *Report of the US National Museum*, Washington 1904.

100 The designs are produced on bags in twined weaving. They illustrate how a recognisably human form, TOP, provides the basis for other designs like that BOTTOM RIGHT where the two joined diamond shapes can be identified as a face only through the intermediate stage of the design BOTTOM LEFT. Wishram and Wasco. Oregon and Washington. 19th century.

Further reading

Bedinger, M. *Indian Silver: Navajo and Pueblo Jewelers* (The University of New Mexico Press, Albuquerque 1973)

Berlant, A. and Kahlenberg M. H. *Walk in beauty, The Navajo and their blankets* (New York Graphic Society 1977)

Brody, J. J. *Mimbres Painted Pottery* (School of American Research, Santa Fe 1977)

Feder, N. *Art of the Eastern Plains Indians* (Brooklyn Museum, New York 1964)

Feest, C. F. *Native Arts of North America* (Thames and Hudson, London 1980)

Frank, L. and Harlow, F. H. *Historic Pottery of the Pueblo Indians, 1600-1880.* (New York Graphic Society, Boston 1974)

Holm, B. *Northwest Coast Indian Art, An analysis of form* (University of Washington Press, Seattle 1965)

King, J. C. H. *Smoking pipes of the North American Indians* (British Museum Publications, London 1977)

King, J. C. H. *Portrait masks from the northwest coast of America* (Thames and Hudson, London 1979)

King, J. C. H. *Artificial Curiosities from the Northwest Coast of America. Native American Artefacts in the British Museum collected on the Third Voyage of Captain Cook and acquired through Sir Joseph Banks* (British Museum Publications, London 1981)

King, J. C. H. *Thunderbird and Lightning, Indian Life in Northeastern North America 1600-1900* (British Museum Publications, London 1982)

Rodee, M. E. *Southwestern Weaving* (University of New Mexico Press, Albuquerque 1977)

Samuel, C. *The Chilkat Dancing Blanket* (Pacific Search Press, Seattle 1982)

Schneider, R. C. *Crafts of the North American Indians: a craftsman's manual* (Van Nostrand Reinhold, New York 1974)

Thomas, D. and Ronnefelt, K. (*ed.*) *People of the First Man, Life Among the Plains Indians in Their First Days of Glory. The first-hand account of Prince Maximilian's expedition up the Missouri River 1833-34. Watercolours by Karl Bodmer.* (E. P. Dutton & Co, New York 1976)

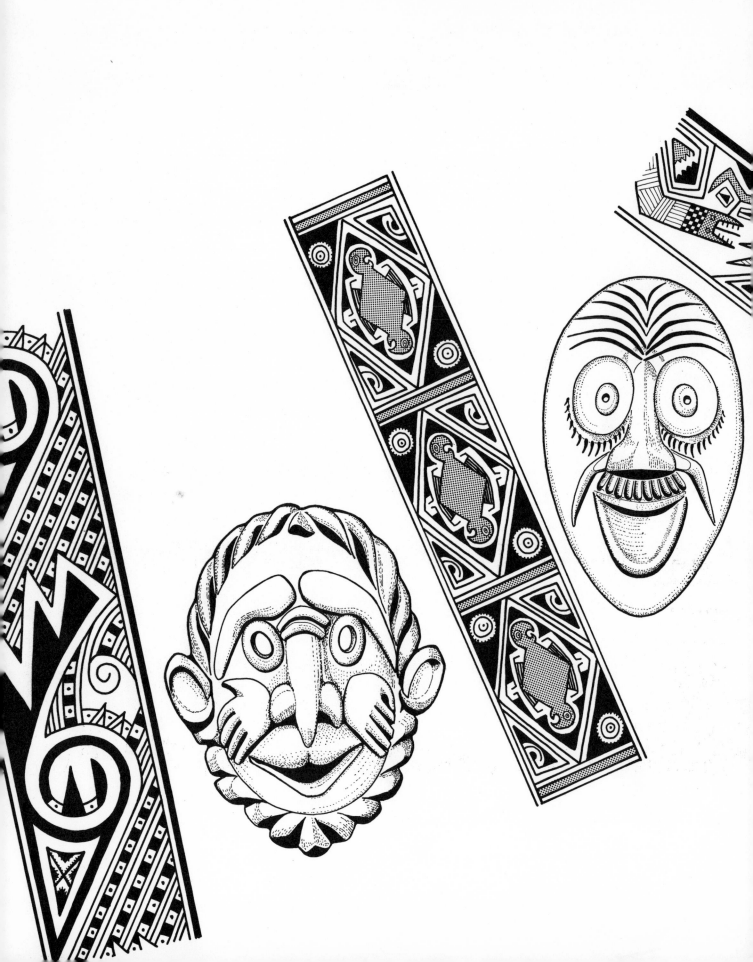

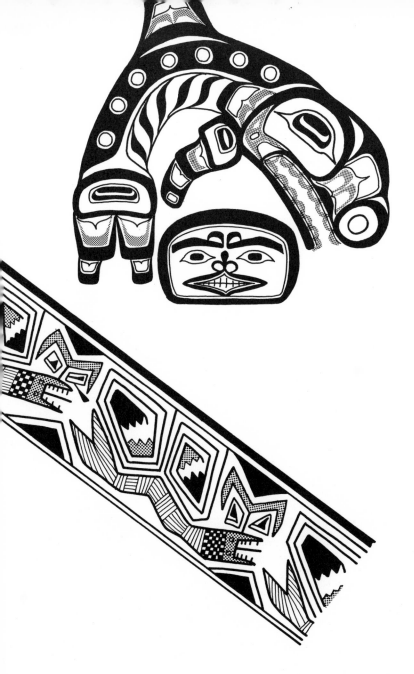

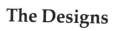

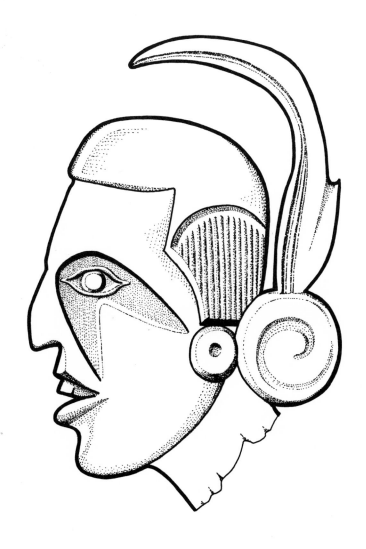

1 Copper ornament from Spiro Mound, Oklahoma. 13th – 18th centuries.

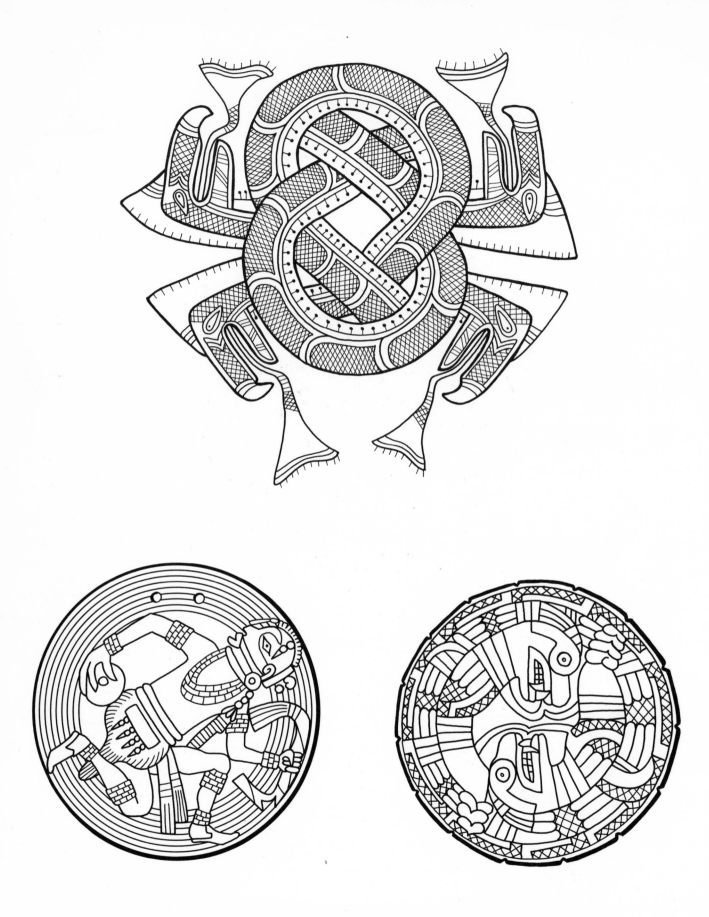

2 Designs from the South-east: TOP the extended design engraved on a conch shell; BELOW LEFT a shell pendant showing a chunkee player, RIGHT a stone palette with a design of two rattlesnakes with plumed heads. 13th – 18th centuries.

3 Pottery with engraved designs from Arkansas. 8th — 18th centuries.

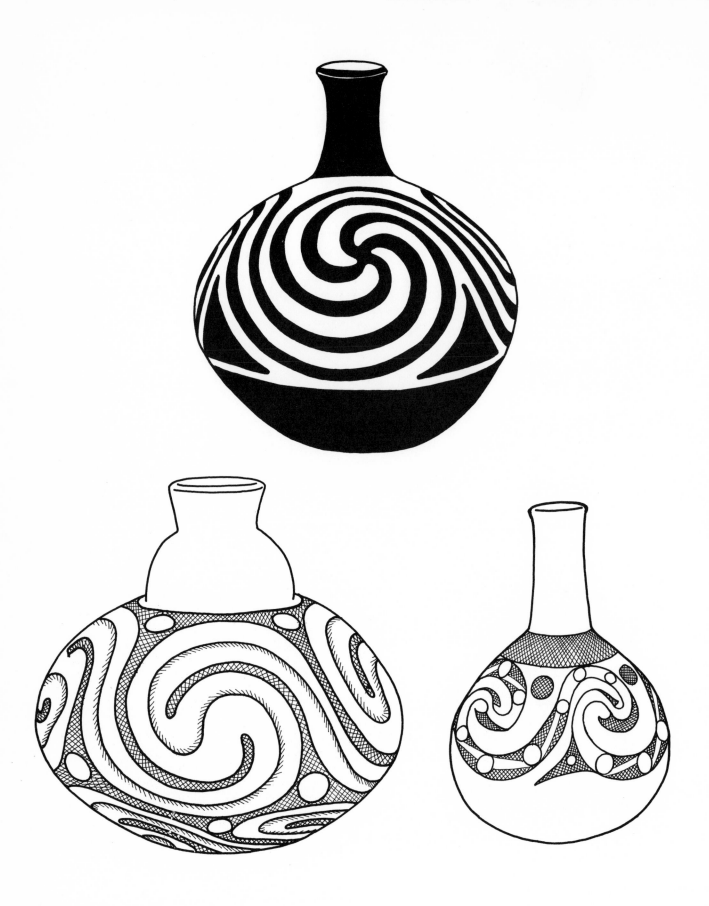

4 Pottery with engraved and painted designs from Arkansas. 8th — 18th centuries.

5 Hohokam pottery with painted designs from Arizona. 11th century.

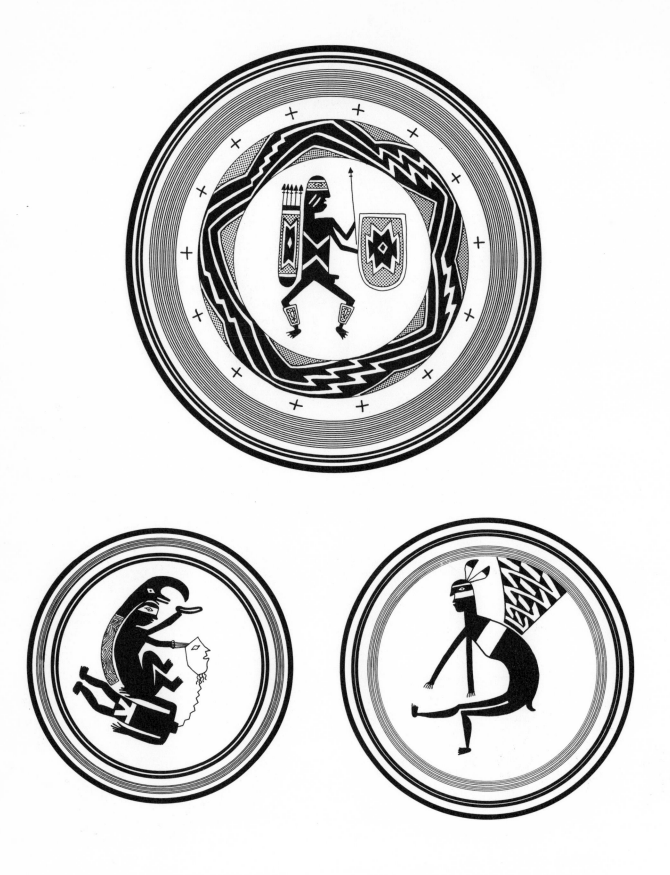

6 Designs painted in black on a white slip on the inside of pottery bowls representing a warrior, a decapitation and a man carrying a basket on his back. Mimbres, New Mexico and Arizona. 9th – 12th centuries.

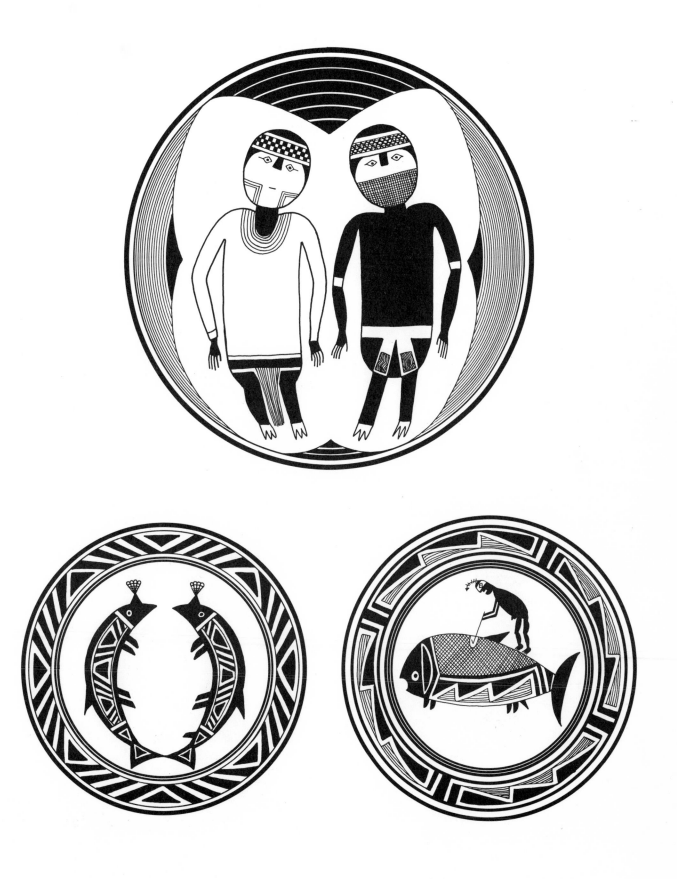

7 On these bowls the arrangement of two figures in a circular field has in each case been satisfactorily resolved. Mimbres, New Mexico and Arizona. 9th − 12th centuries.

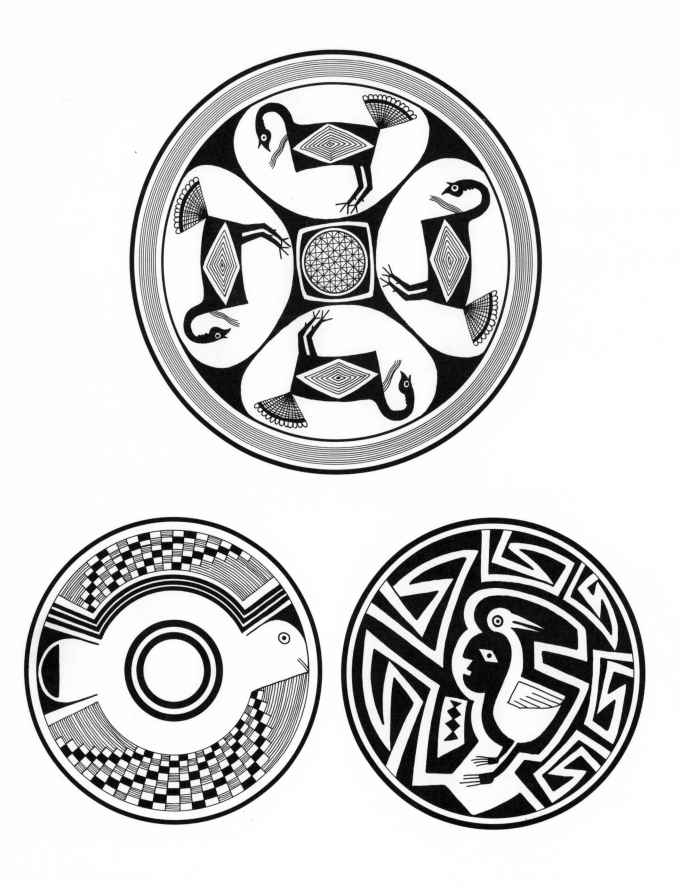

8 Designs painted in black on a white slip on the inside of pottery bowls. BOTTOM LEFT the sweep of wings is suggested by the chequer pattern. Mimbres, New Mexico and Arizona. 9th – 12th centuries.

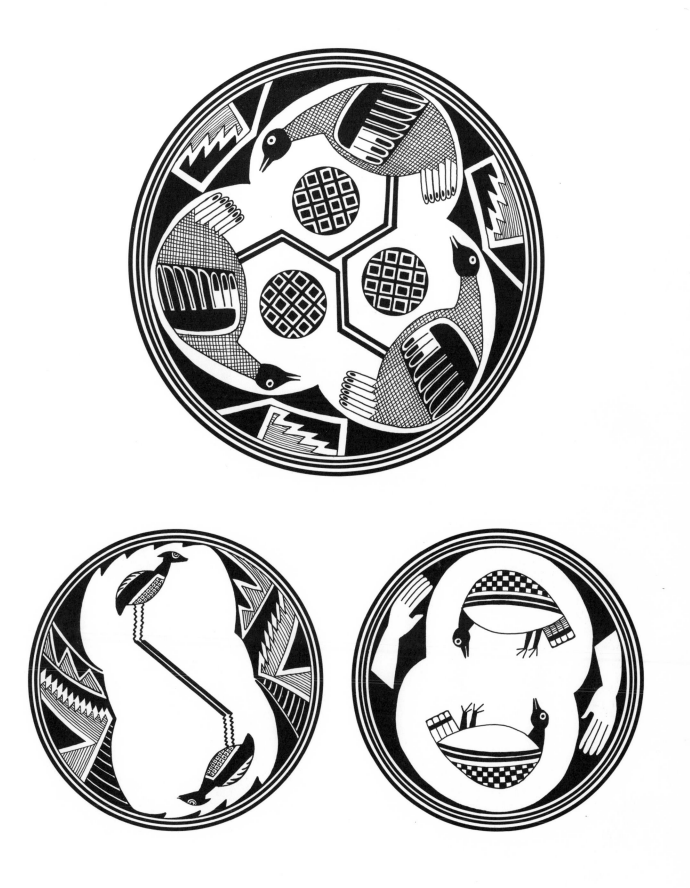

9 The masking of part of the circular field by geometric and other designs allows the balanced placing of the paired birds BOTTOM. Mimbres, New Mexico and Arizona. 9th – 12th centuries.

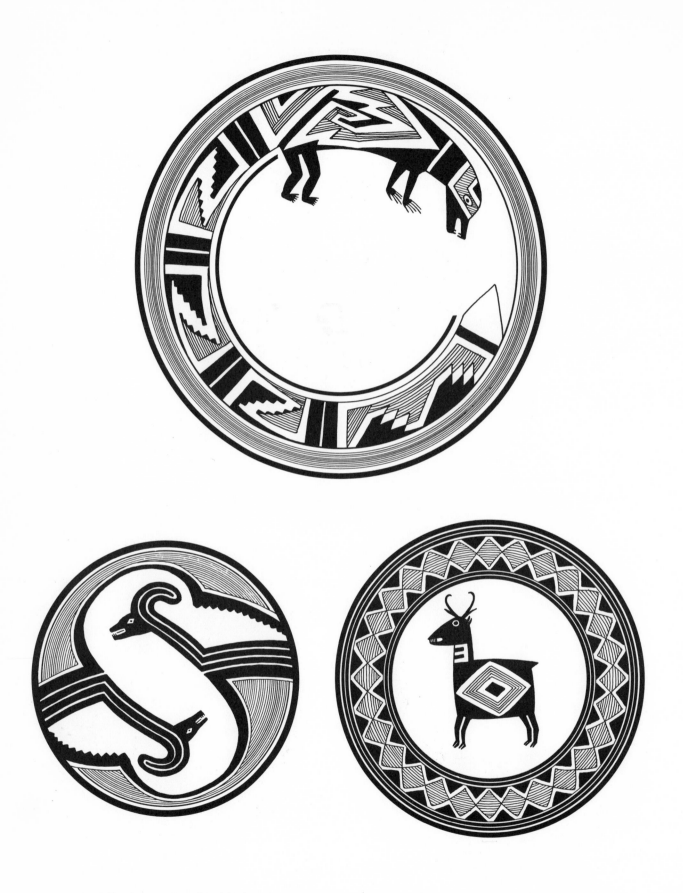

10 Designs painted in black on a white slip on the inside of pottery bowls. The animal circling the design TOP may be a racoon. Mimbres, New Mexico and Arizona. 9th – 12th centuries.

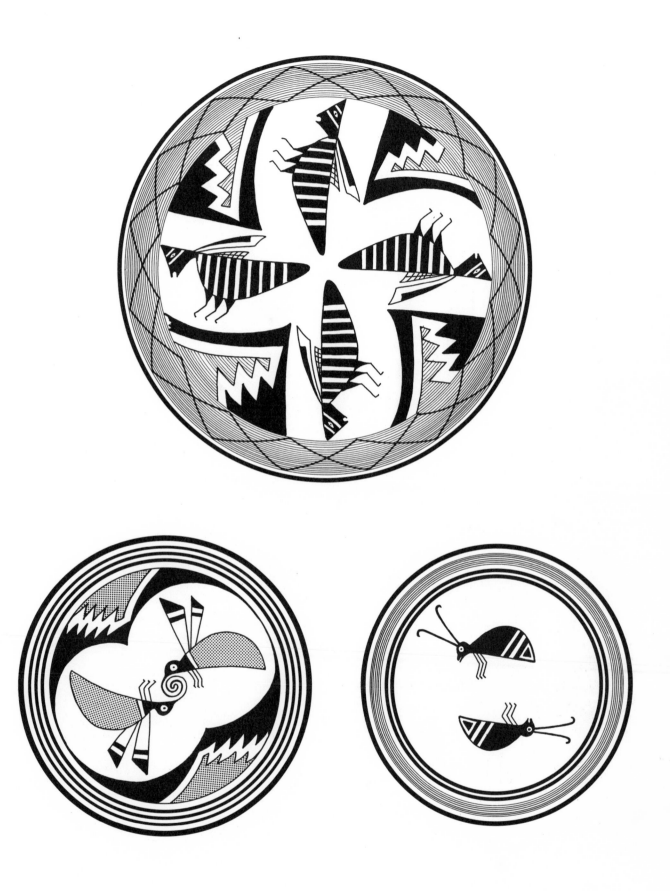

11 The insects represented in the design TOP may be grasshoppers. The design BOTTOM LEFT is painted in black and red on a white slip. Mimbres, New Mexico and Arizona. 9th – 12th centuries.

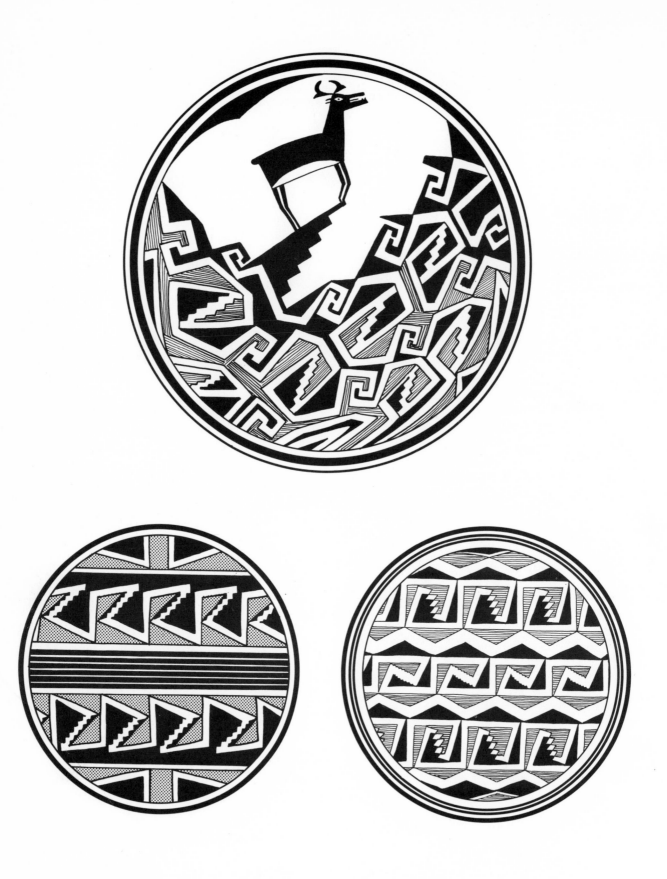

12 Designs painted on the inside of pottery bowls. The antelope TOP is clearly represented standing on a rocky outcrop. Mimbres, New Mexico and Arizona. 9th – 12th centuries.

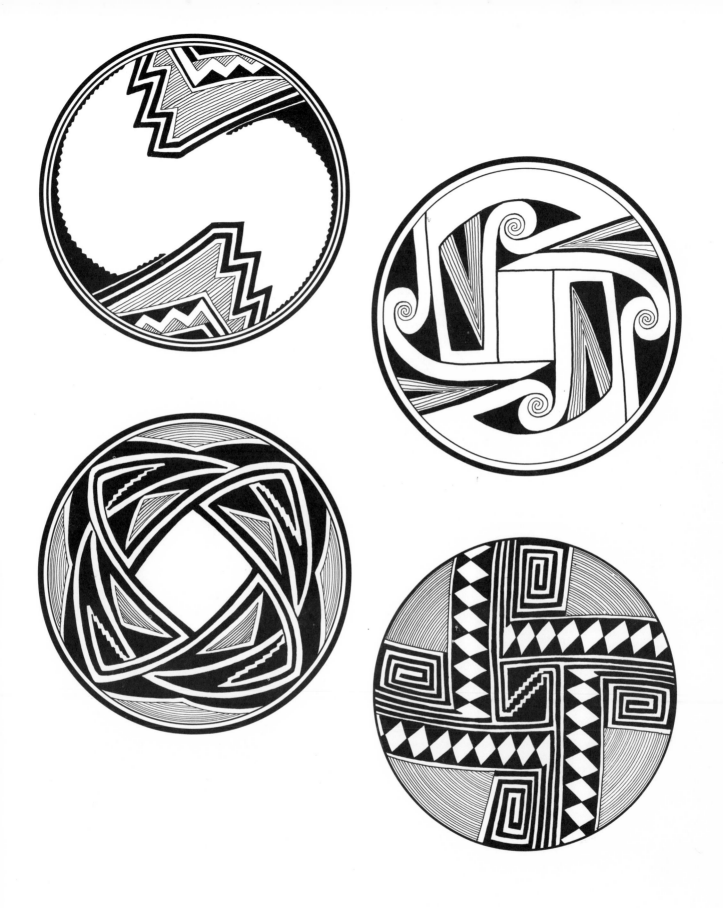

13 Geometric designs painted in black on a white clay slip on the inside of pottery bowls. Mimbres, New Mexico and Arizona, 9th – 12th centuries.

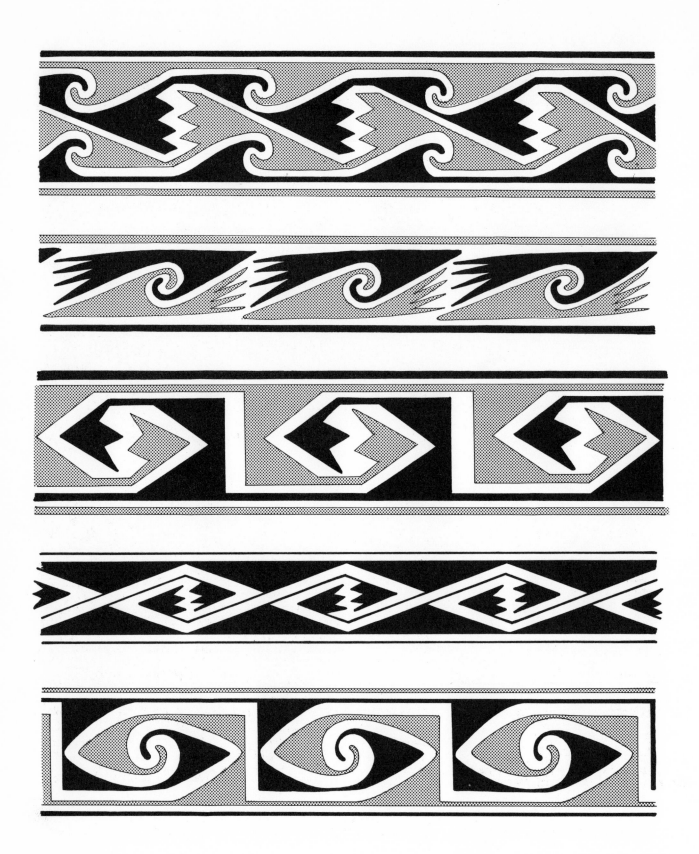

14 Painted border patterns on pottery from Casas Grandes, the South-west. 12th – 13th centuries.

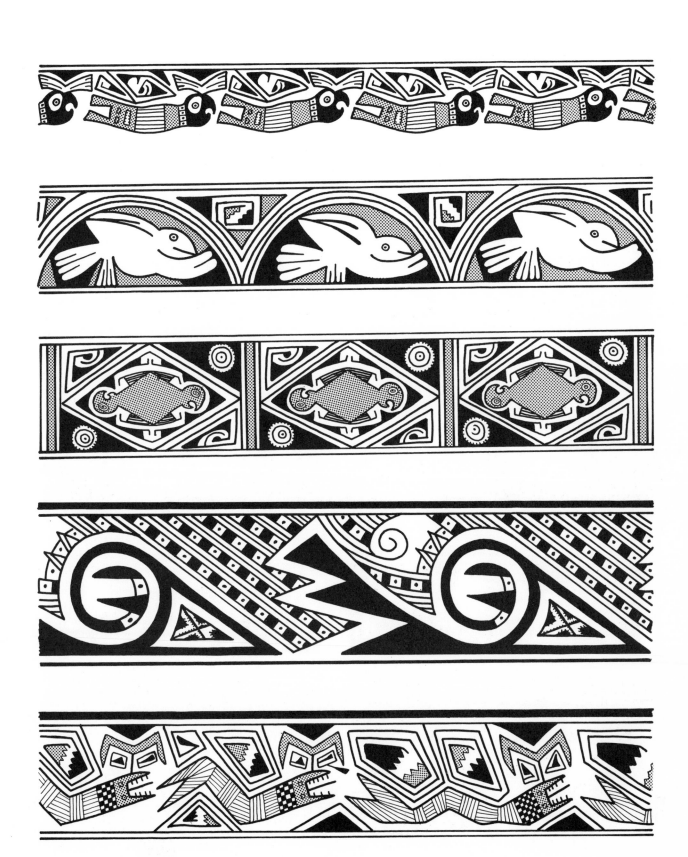

15 Painted border patterns with macaw- and serpent motifs on pottery from Casas Grandes, the South-west. 12th – 13th centuries.

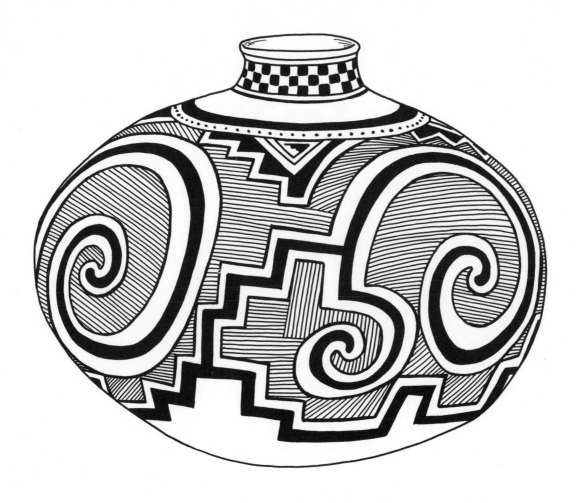

16 Painted designs on pottery from the South-west. 11th — 13th centuries.

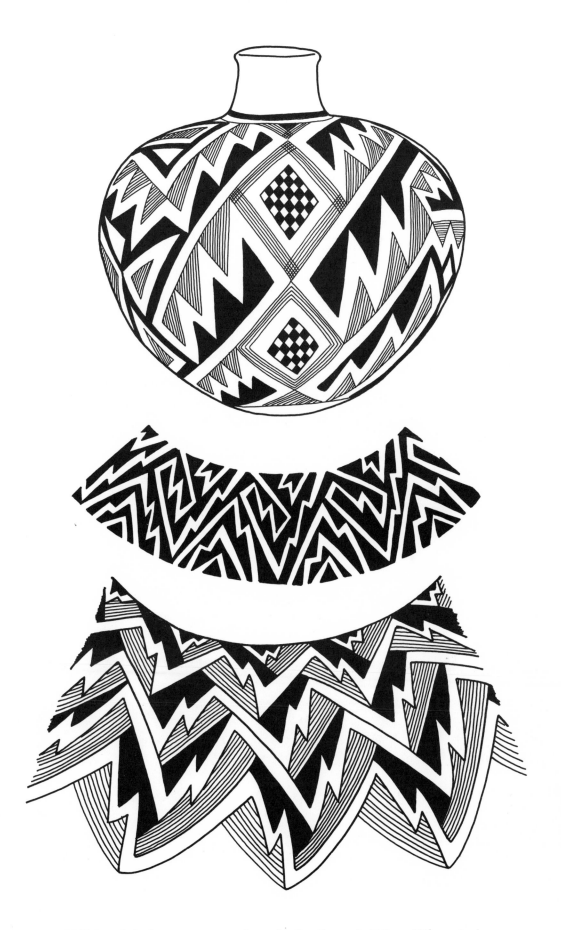

17 Painted designs on pottery from the South-west. 11th – 13th centuries.

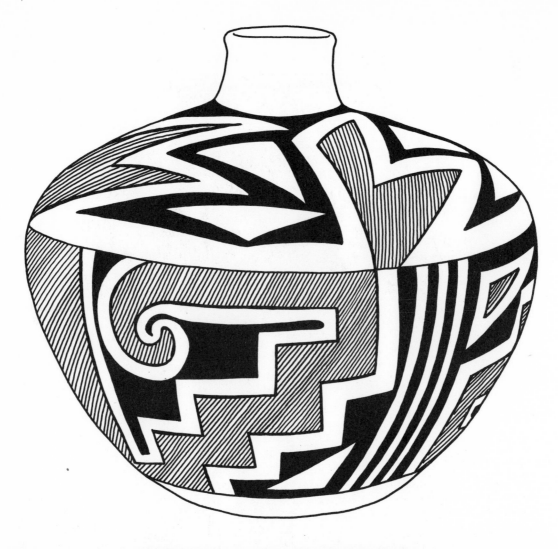

18 Simple geometric pottery patterns painted in black on a white slip. TOP 12th – 13th centuries; BELOW 19th century. New Mexico.

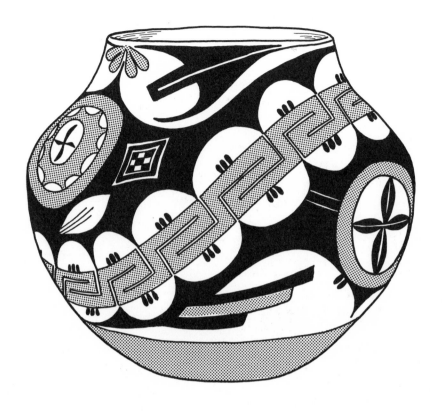

19 TOP Water jar painted in black and red on a white slip; BELOW detail of the design on a
similar vessel. Acoma Pueblo, New Mexico. 19th century.

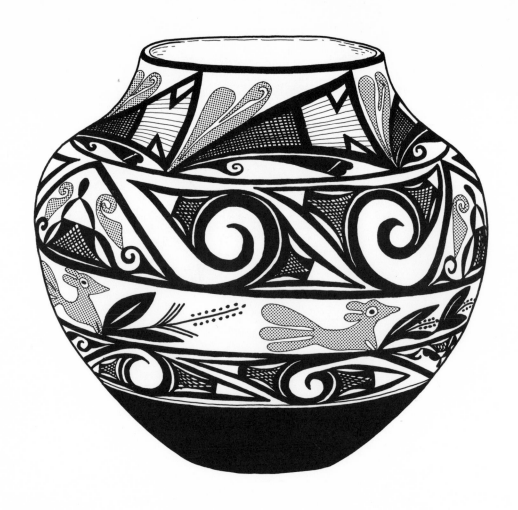

20 TOP Water jar painted in black and red on a white slip; BELOW detail of the design on a similar vessel. Acoma Pueblo, New Mexico. 19th century.

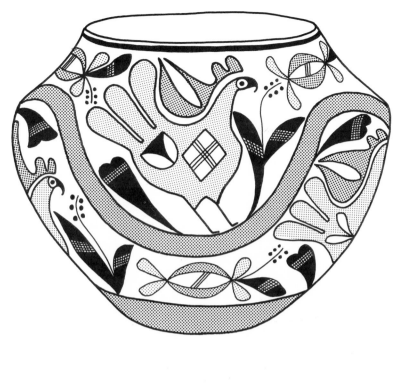

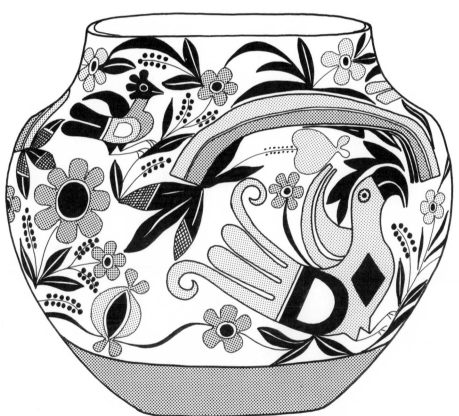

21 TOP Made in 1969, this water jar is an example of the revival of earlier designs of the type shown BELOW, which was made at the end of the 19th century. Acoma Pueblo, New Mexico.

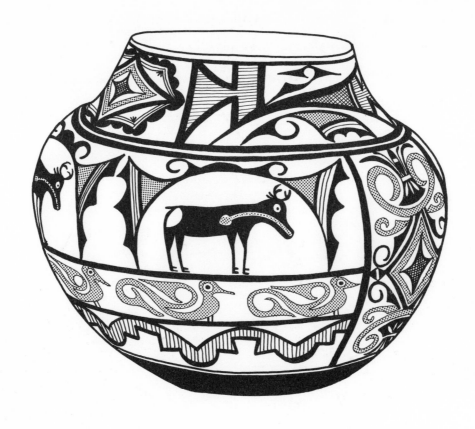

22 TOP Water jar painted in black and red on a white slip; BELOW detail of the design on a similar vessel. Zuni Pueblo, New Mexico. 19th century.

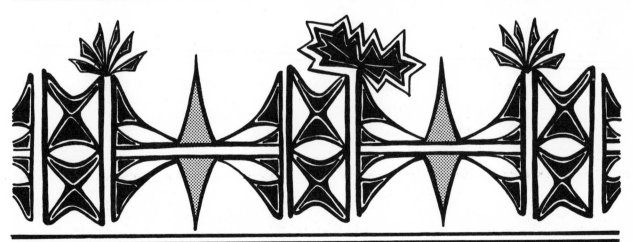

23 Painted motifs from 19th- and 20th-century pottery in the South-west.

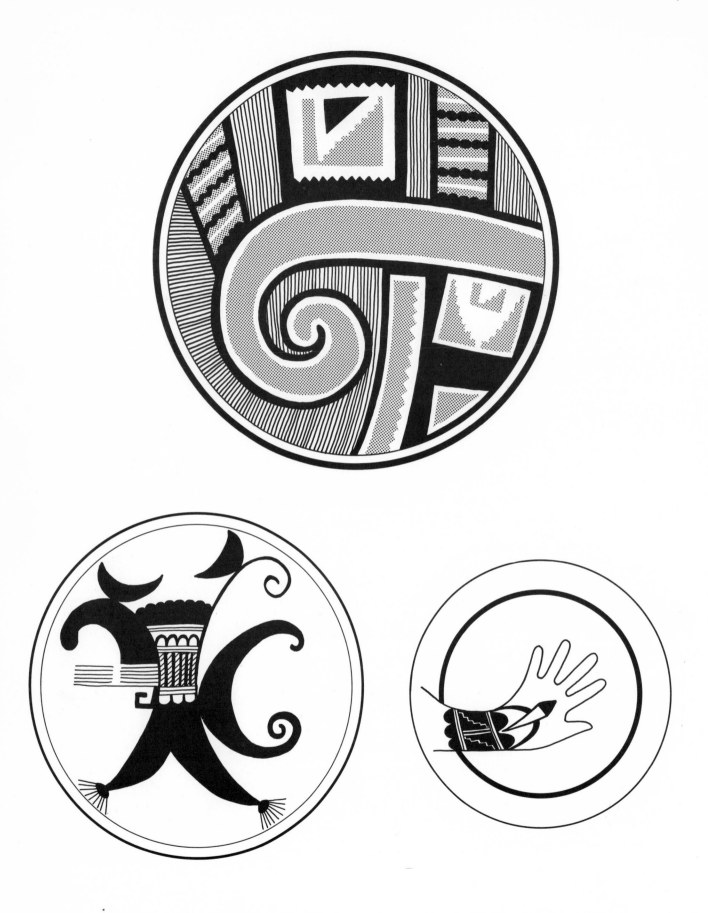

24 Designs painted on the inside of pottery bowls from Arizona. 14th − 17th centuries.

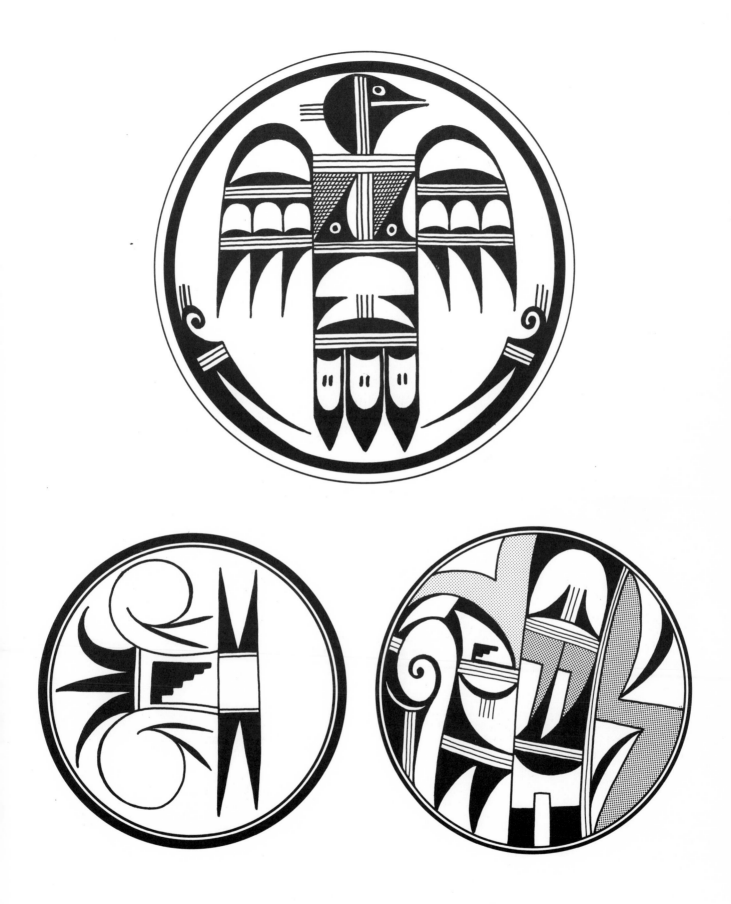

25 Designs painted on the inside of 20th-century pottery bowls using traditional motifs.
Hopi, Arizona.

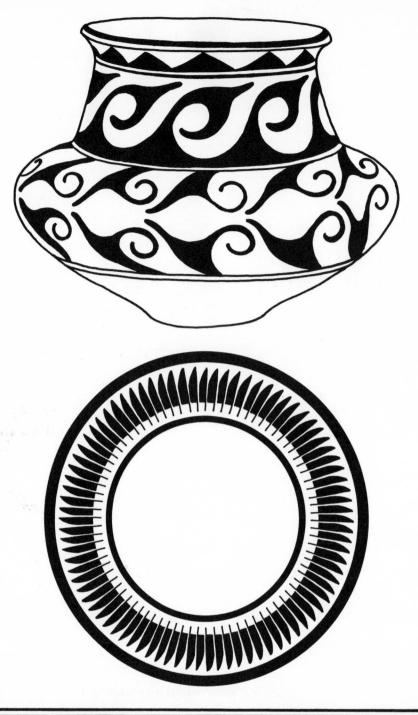

26 20th-century pottery designs using traditional motifs.

27 20th-century pottery designs using traditional motifs.

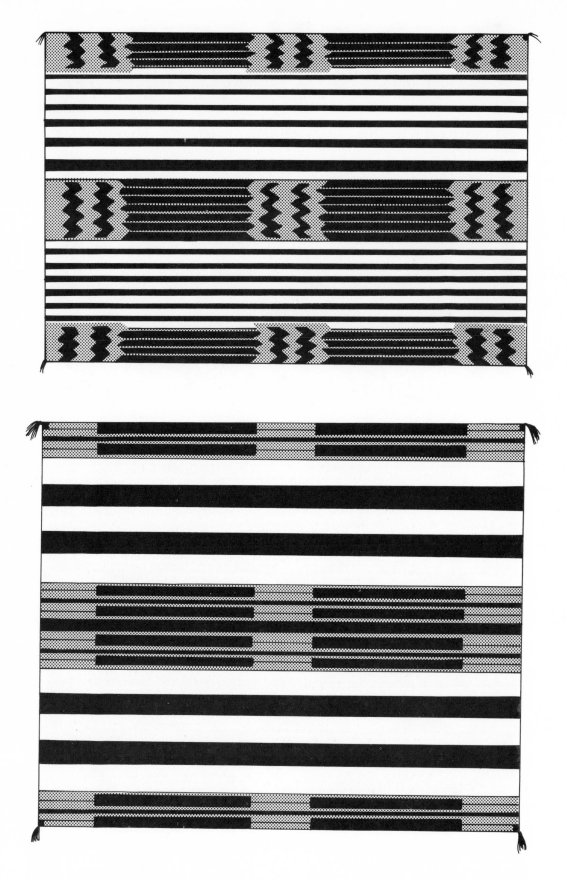

28 — 29 Navajo blankets in the classical pattern consisting of five stripes and nine blocks. The colours are the natural shades of wool with blue and red and some green and yellow. New Mexico and Arizona. 19th century.

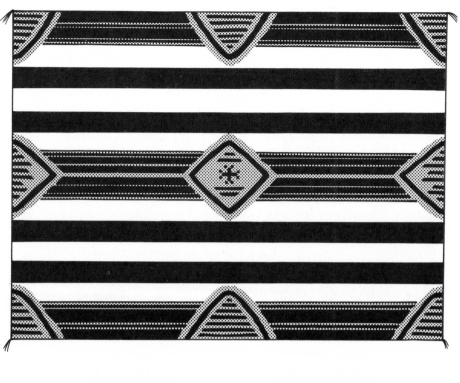

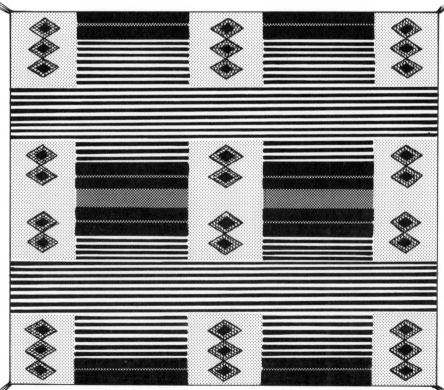

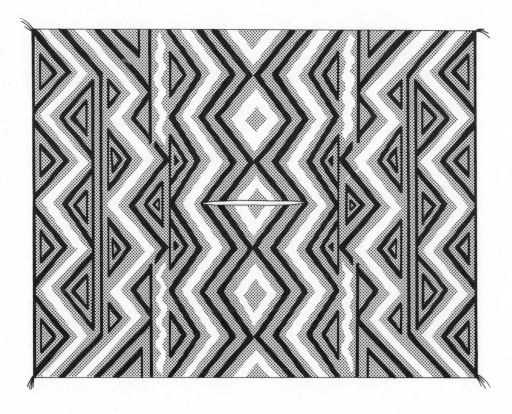

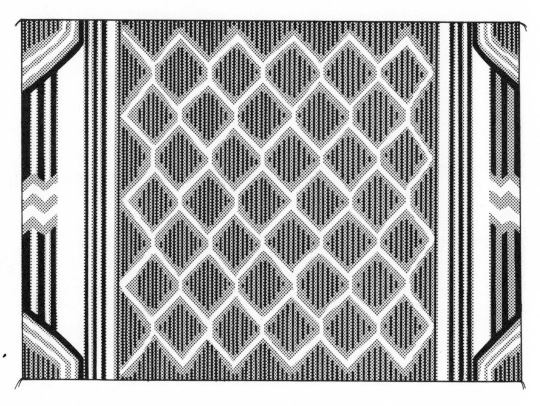

30 TOP Navajo poncho; the shift of alignment in the pattern is a typical effect. BELOW Navajo blanket in the classical style. New Mexico and Arizona. 19th century.

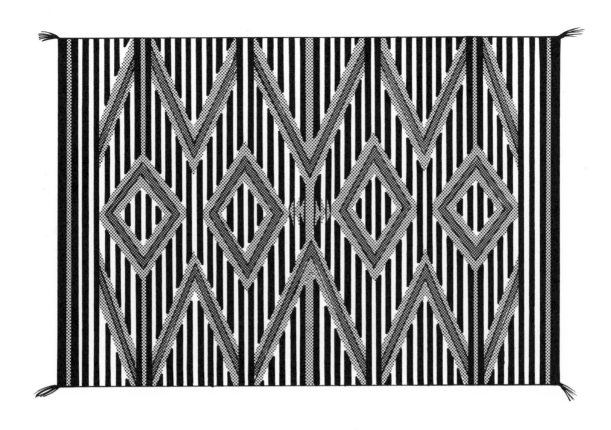

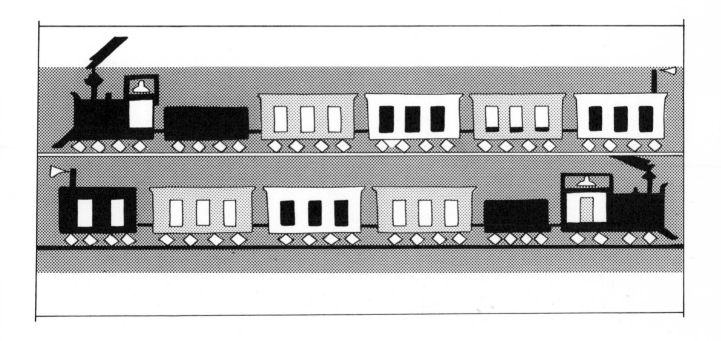

31 TOP Navajo blanket known as 'eye-dazzler'; the green and red diamond pattern on a
background of black and white stripes creates an illusion of movement. BELOW detail from
a pictorial blanket — the coming of the railway had a great influence
on Navajo life. 19th century.

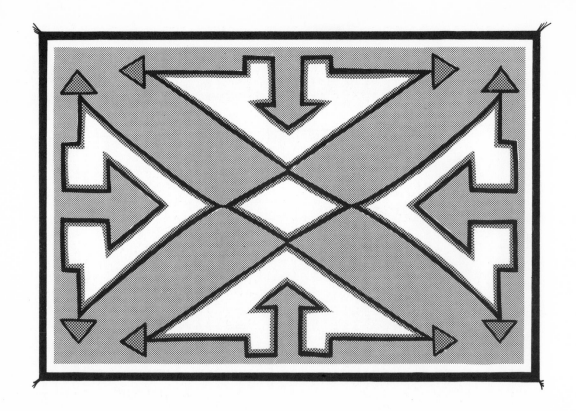

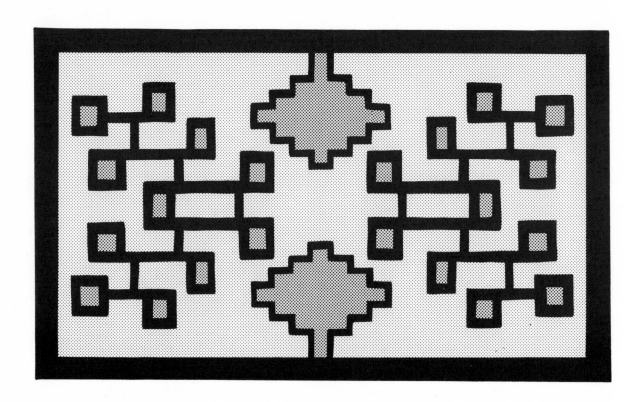

32 Navajo rugs of the Transitional Period in the early 20th century.

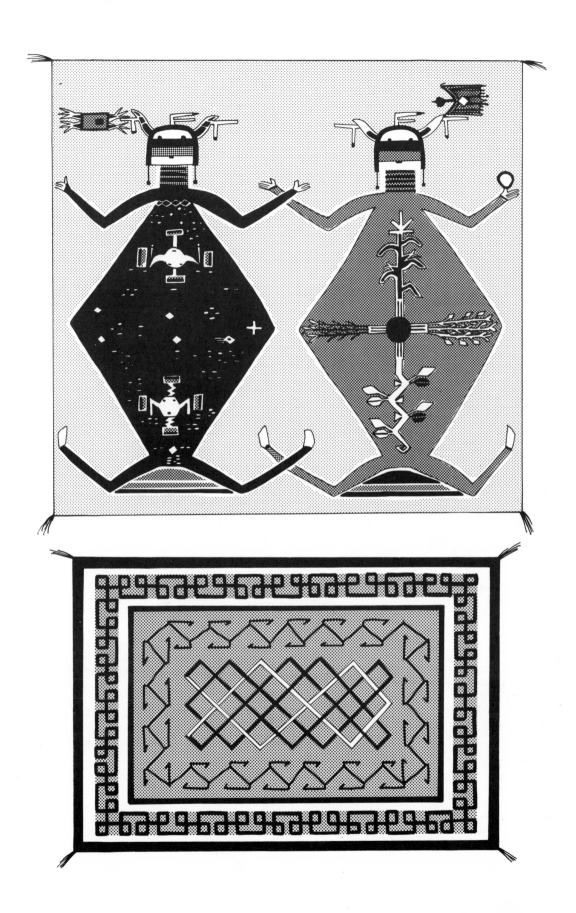

33 TOP Navajo rug from the early 20th century. The motif of Mother Earth and Father Sky is taken from the sacred sand paintings. BELOW Navajo rug from the 1930s.

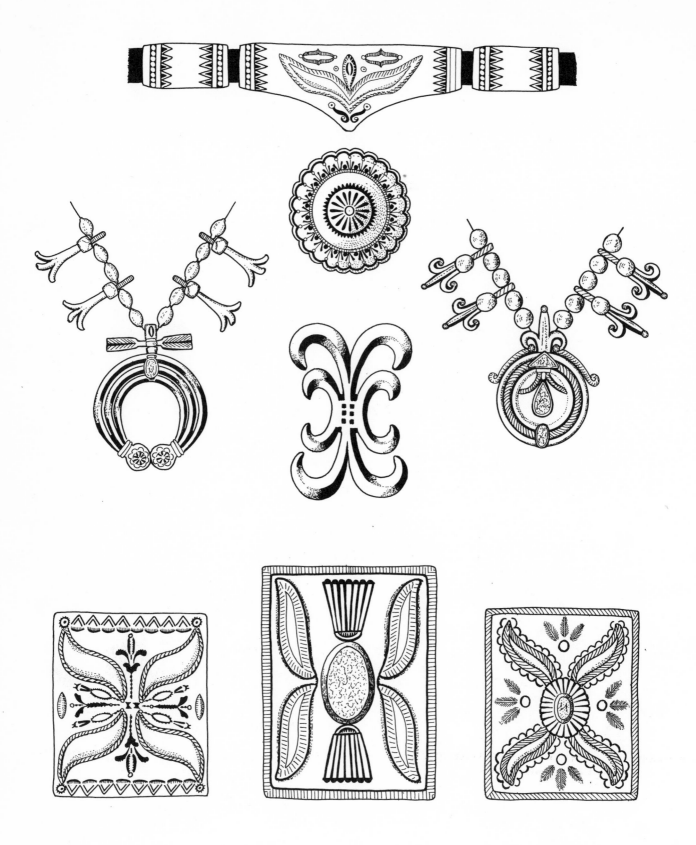

34 Navajo silver work of the late 19th and 20th century. Some of the jewellery is inlaid with turquoise. Most of the designs are based on the flower and leaf of the maize and squash plants. New Mexico and Arizona.

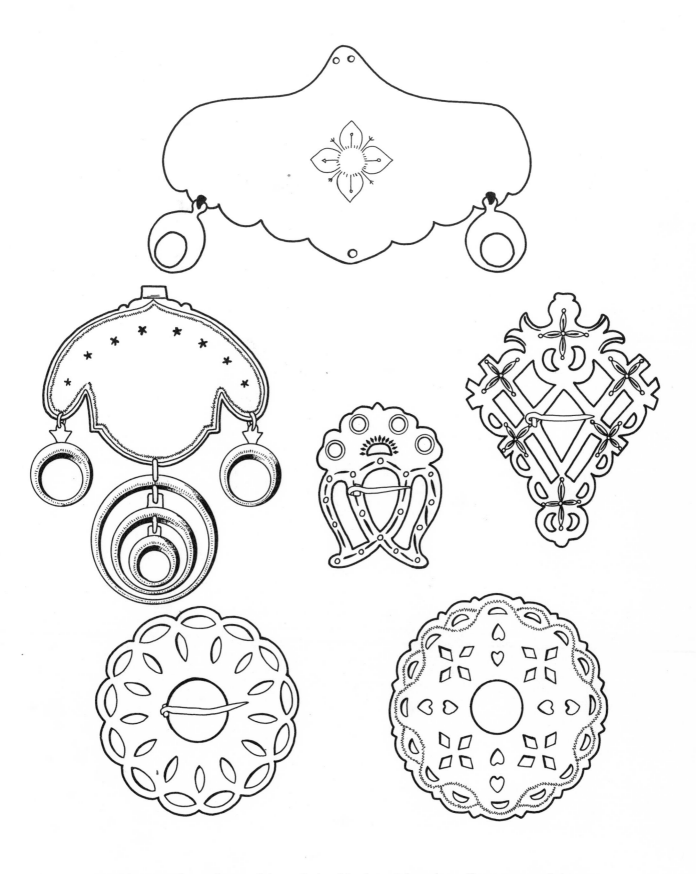

35 Silver work in the tradition of the North-east based on European prototypes, particularly from Scotland. The pectorals TOP and CENTRE LEFT may be derived from Spanish bridle mounts. Late 18th and 19th centuries.

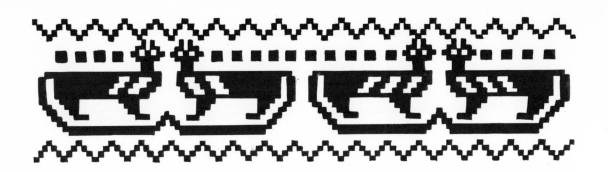

36 The Underwater Panther, a motif from the mythology of the Woodlands Indians in the North-east: TOP in bead work, CENTRE on a mat of woven reeds and BOTTOM as part of the design on a twined bag (see diagram 37). 19th century.

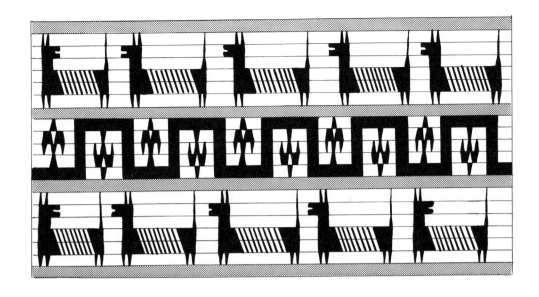

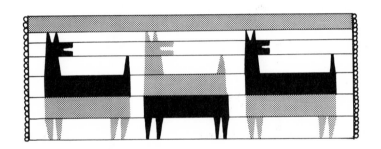

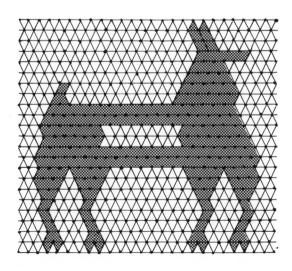

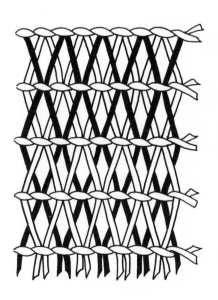

37 Designs of deer and Thunderbird motifs: TOP and CENTRE in quill work; the diagram illustrates the method. BOTTOM The deer is part of the design of a twined bag. The method of twining in two colours is shown in the diagram. The Great Lakes. 19th century.

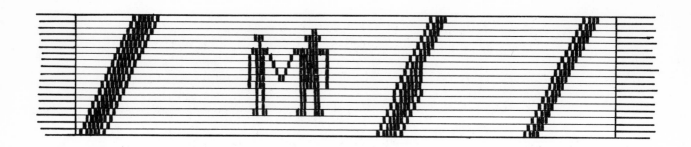

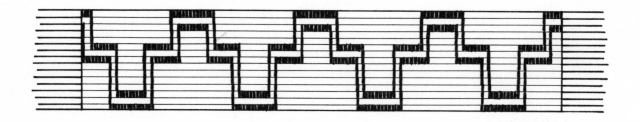

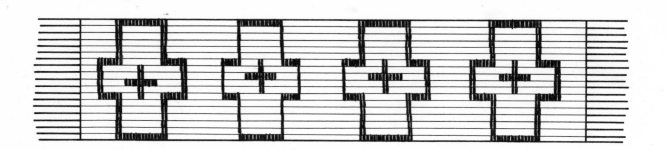

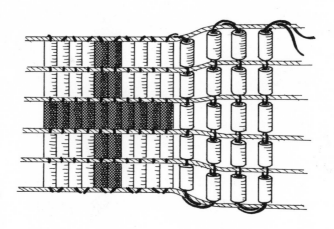

38 The designs on these 'Wampum belts' are pictographs recording treaties between the Indians and the Europeans. The diagram shows how the shell beads are woven on a warp of fibre cords. The Great Lakes. 19th century.

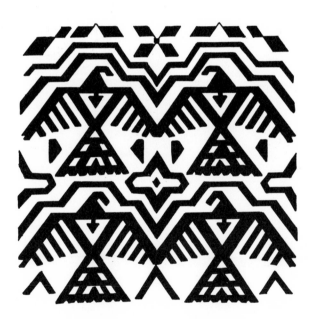

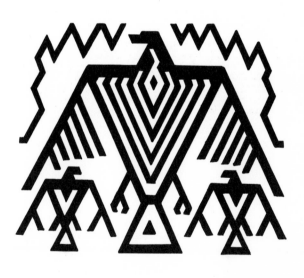

39 Variations on the Thunderbird and Lightning motif from the mythology of the Woodlands Indians. The Great Lakes. 19th century.

40 Patterns on woven burden straps with false moosehair embroidery from the Great Lakes. 18th century.

41 Patterns based on designs of finger-woven sashes from the Great Lakes. 18th — 19th centuries.

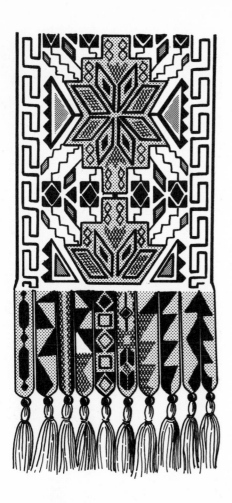

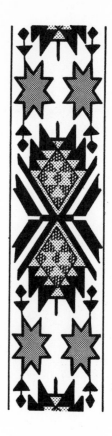
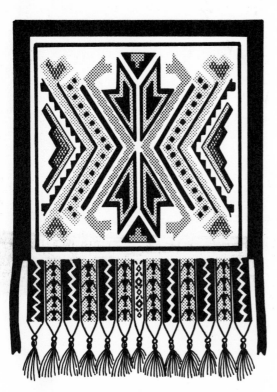
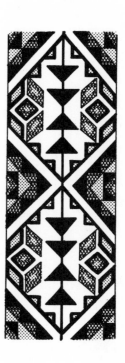

42 – 43 Designs based on loom-woven bead work on sashes, bags etc. from the Great Lakes. 19th century.

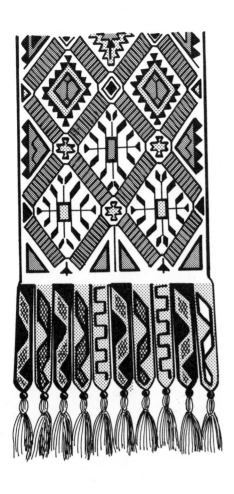

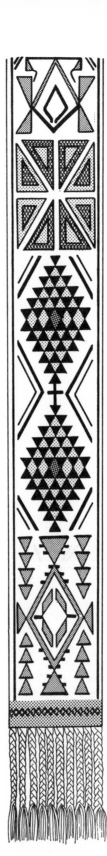

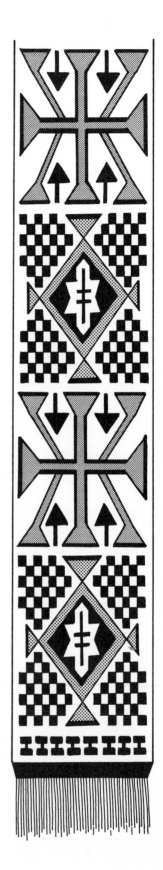

44 The double-curve motif is particularly characteristic of the art in the North-east. These designs are taken from Montagnais birch bark containers. Early 20th century.

45 Double-curve and plant motifs in bead work and engraving from the North-east. 18th — 19th centuries.

46 European influenced floral designs in silk and moosehair embroidery. The enlarged detail shows the line work of the embroidery. Canada. 19th century.

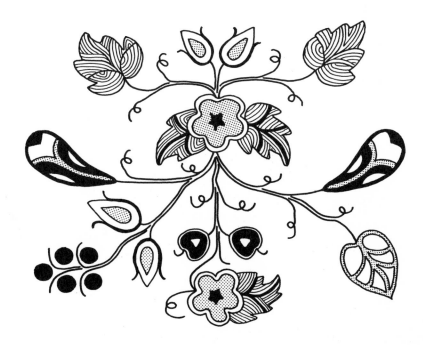
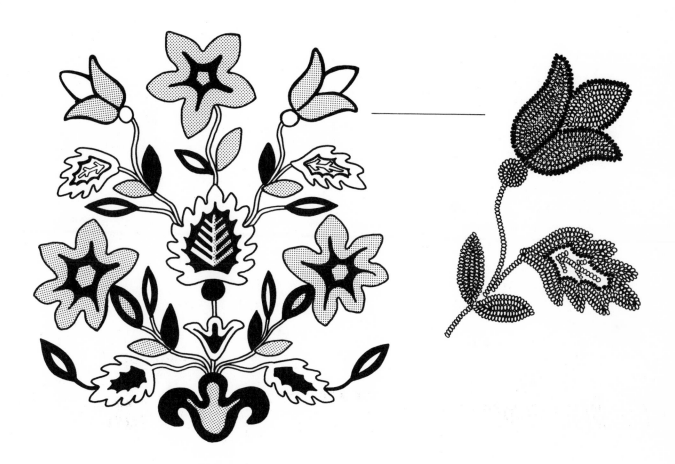

47 European influenced floral designs in bead work embroidery. The enlarged detail shows how the strings of beads are arranged. Canada. 19th – 20th centuries.

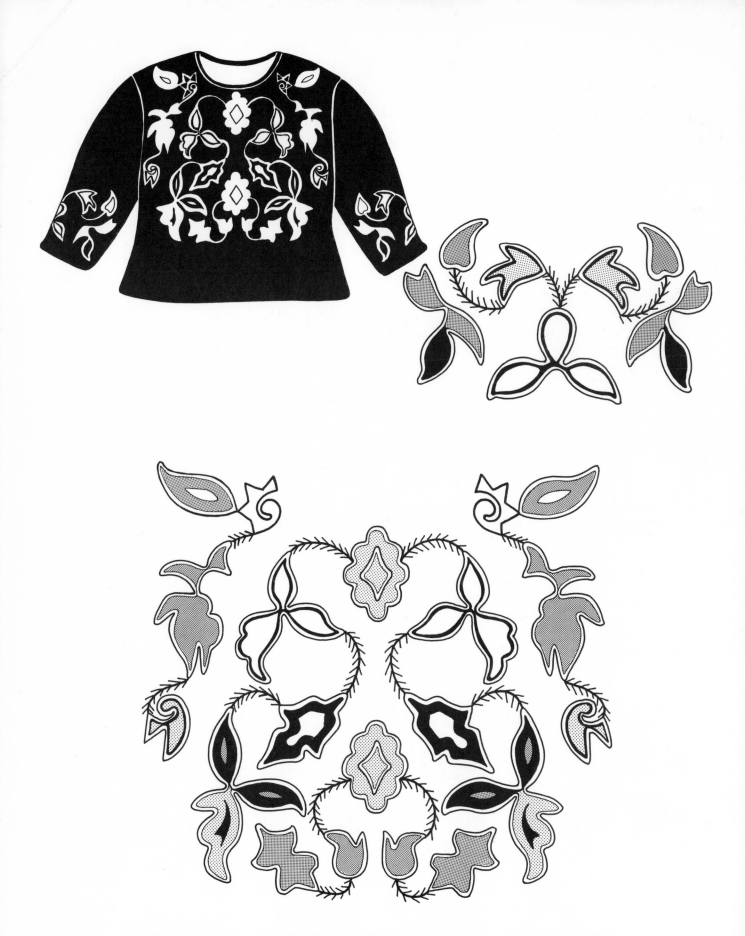

48 Winnebago man's shirt in black wool with bead work appliqué. Details of the design on the front and sleeves are shown BELOW. The back is decorated with similar designs. The Great Lakes. 19th century.

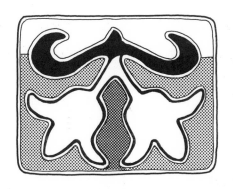

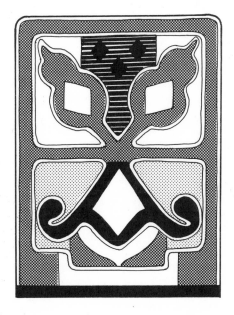

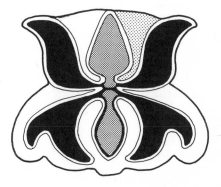

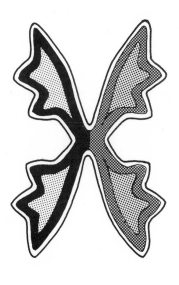

49 Bead work panels with double-curve and stylized floral designs. The panels were attached to leather or cloth on clothing, bags etc. Southern Great Lakes. 19th century.

50 Silk ribbon from France first reached the North-east in the 18th century as part of the fur trade. Indian women used these to make appliquéd panels which were sewn onto garments of black, red or blue cloth. Southern Great Lakes. 19th – 20th centuries.

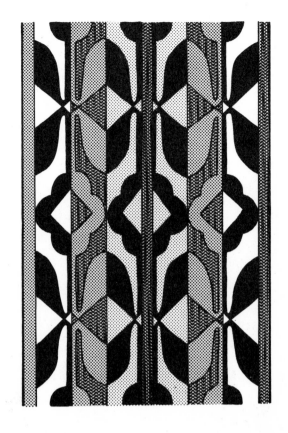
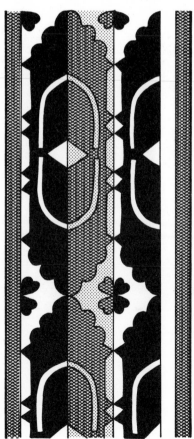
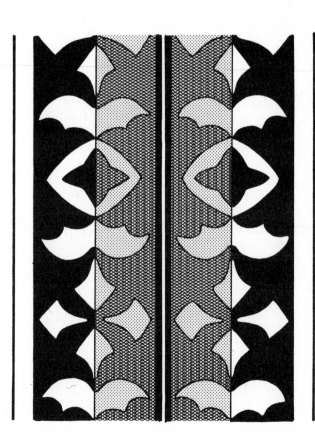

51 Variations on the double-curve motif, cut out and applied, frequently occur on these panels which are made up of several appliquéd ribbons stitched together.

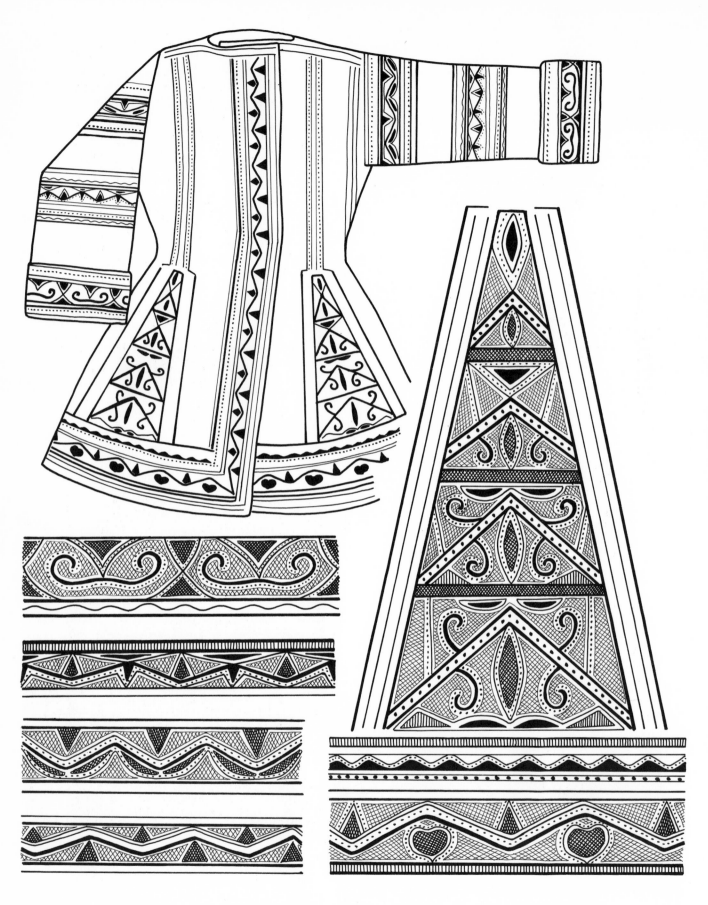

52 Hunting coat of caribou skin. The cut of the coat may have been inspired by the style of coat worn by the European traders. The details show the painted designs. Naskapi, Quebec and Labrador. *c.*1840.

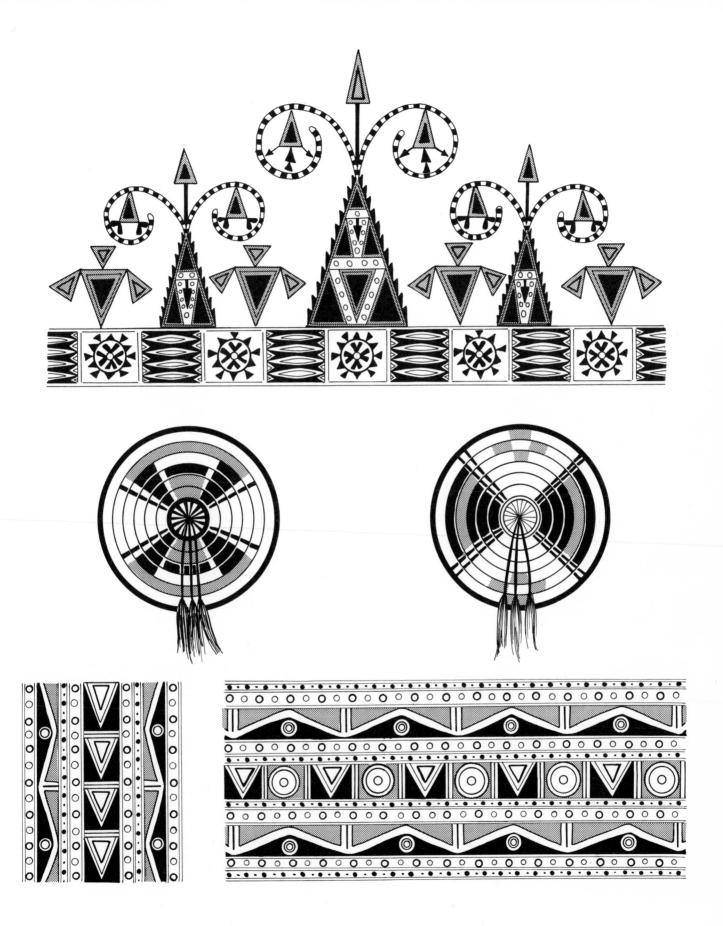

53 Painted designs and quill work rosettes from a Métis skin coat. The design TOP can be interpreted as representing four men hunting three antlered animals. 19th century.

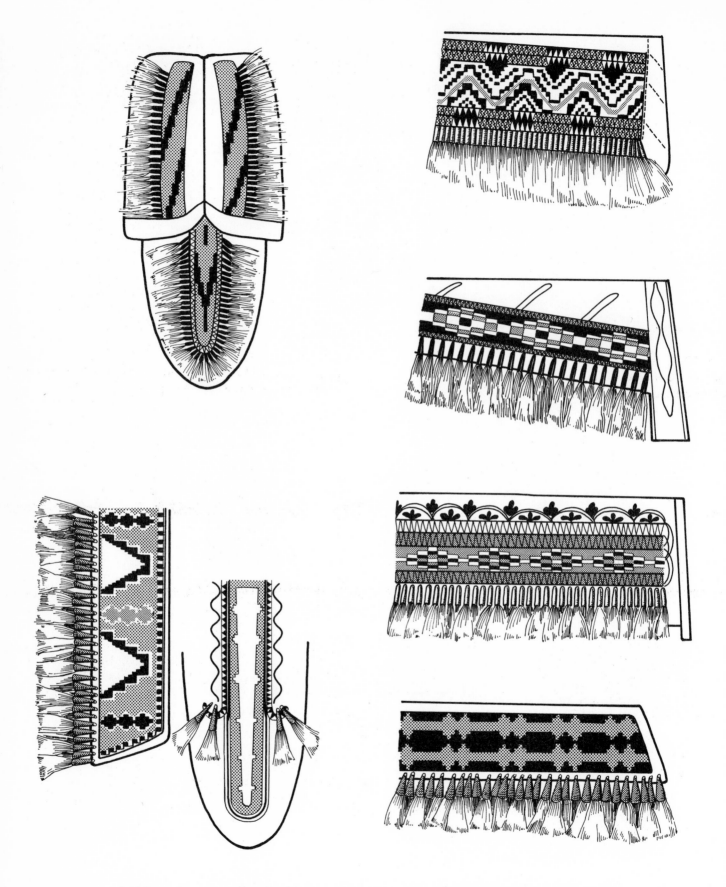

54 Moccasins: toe and cuff designs in quill work with tassels of hair-filled metal cones. Huron and Cree, The Great Lakes. 18th — 19th centuries.

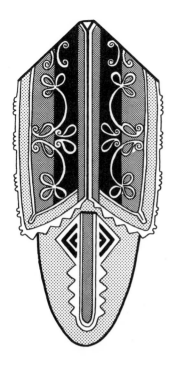
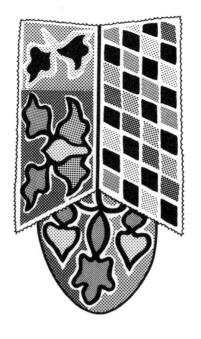
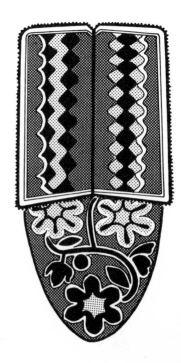
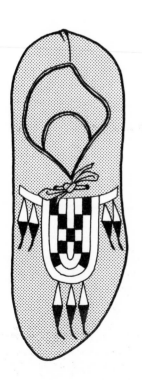
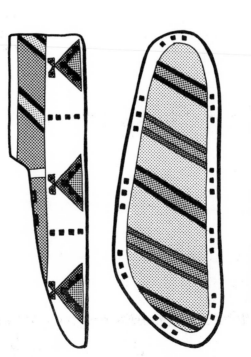
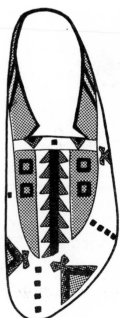

55 TOP Moccasins decorated with ribbon and bead work from the Great Lakes. BOTTOM LEFT
20th-century moccasin decorated in quill work with a stylized feather design; RIGHT
Western Sioux moccasin totally covered in bead work including the sole. *c.*1890.

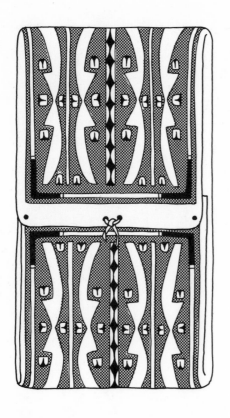

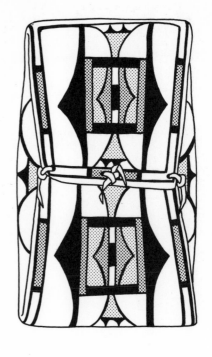

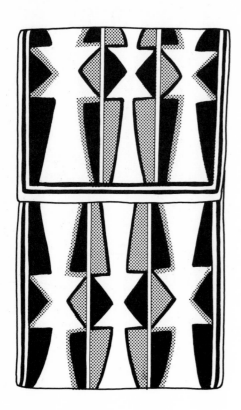

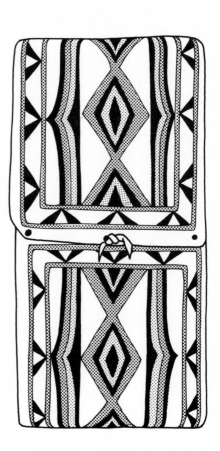

56 — 57 Painted rawhide containers, folded rather like envelopes and known as 'parfleche' were used by the Plains Indians for carrying. 19th — 20th centuries.

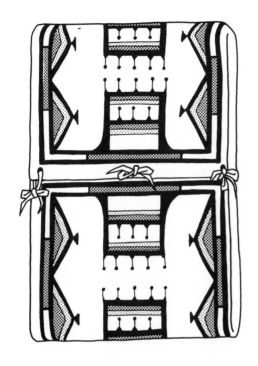
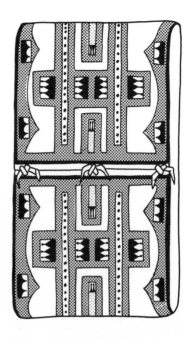
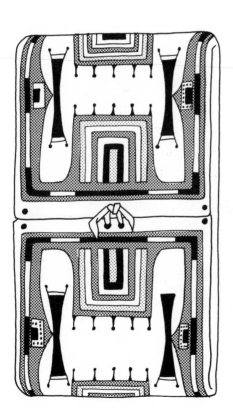
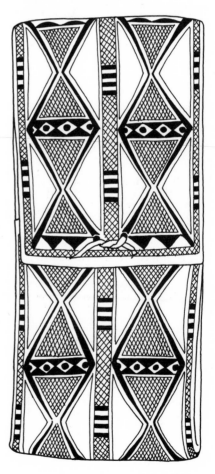

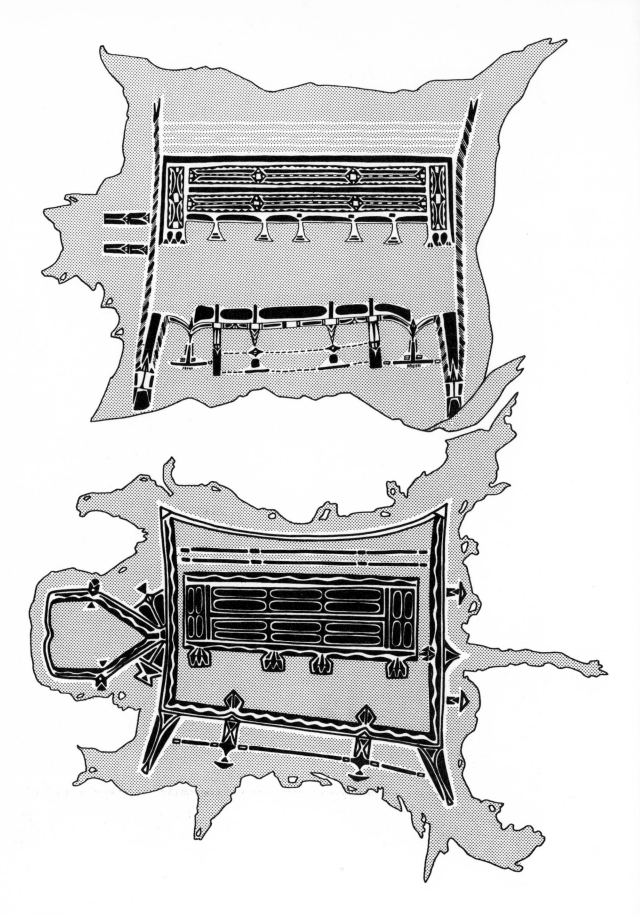

58 Painted hides used as cloaks by the Plains Indians. Sioux and Crow. 19th century.

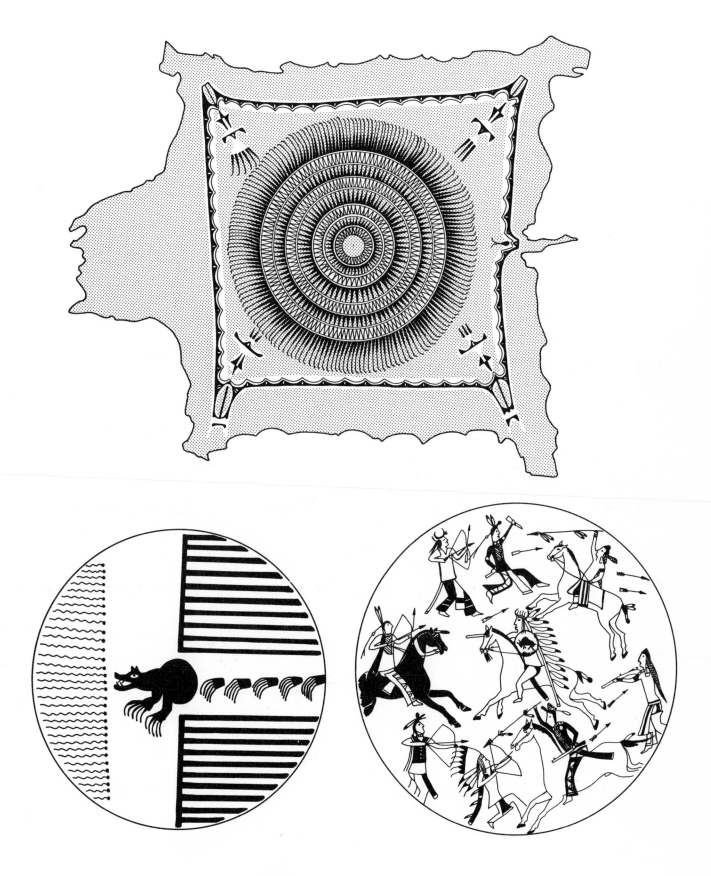

59 TOP Buffalo hide painted with the feathered circle pattern. BELOW Painted shield covers: LEFT a charging bear facing a hail of bullets, RIGHT a battle scene. Sioux, North and South Dakota; Kiowa, Oklahoma. 19th century.

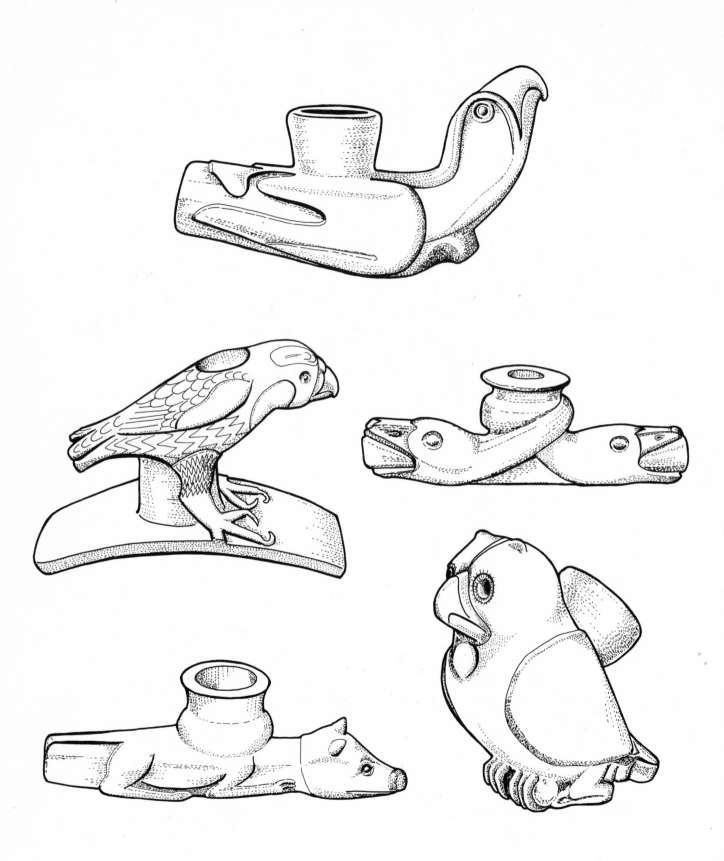

60 Pipes carved in stone. 100BC − 1200AD.

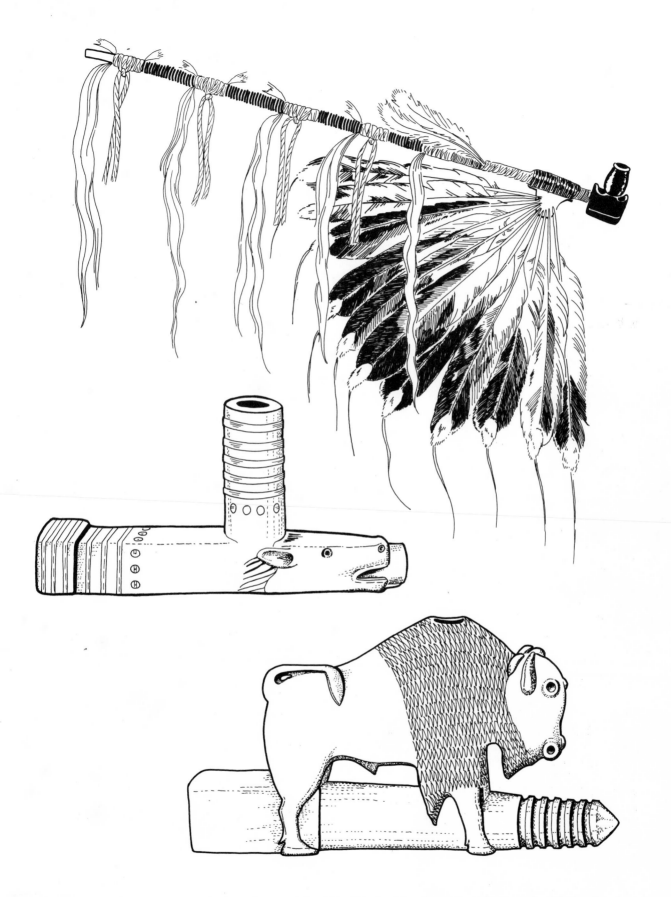

61 TOP Ceremonial pipe; the stone bowl is fitted with a long stem decorated with beads, feathers and cords. Crow, Montana. *c.*1850. BELOW Two pipe bowls carved in stone. Eastern Sioux, Minnesota and Cheyenne, Wyoming. 19th century.

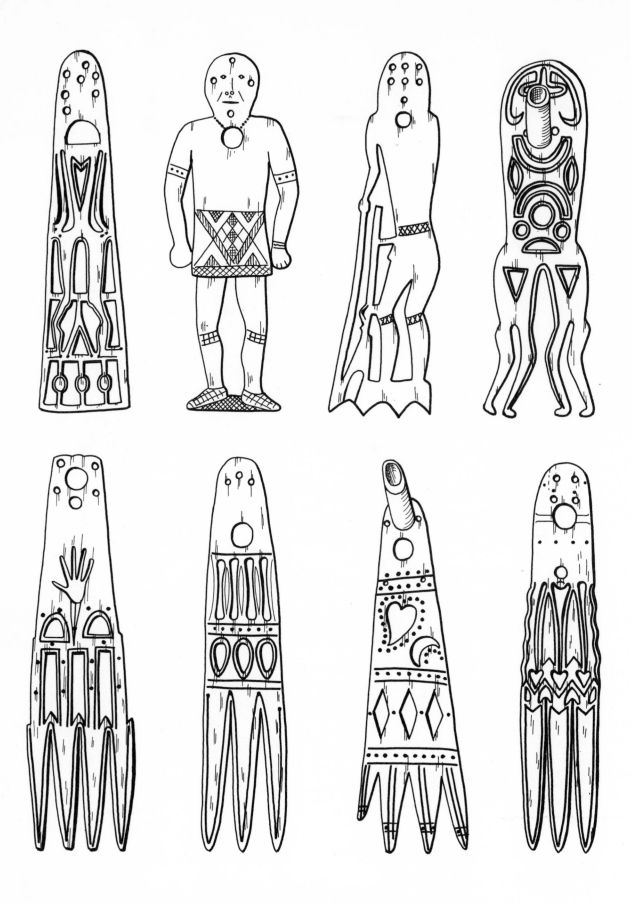

62 Elk antler 'roach spreaders' were used to support elaborate hair ornaments. The teeth kept the porcupine roach fanned out and the holes and sockets held feathers etc. 19th — 20th centuries.

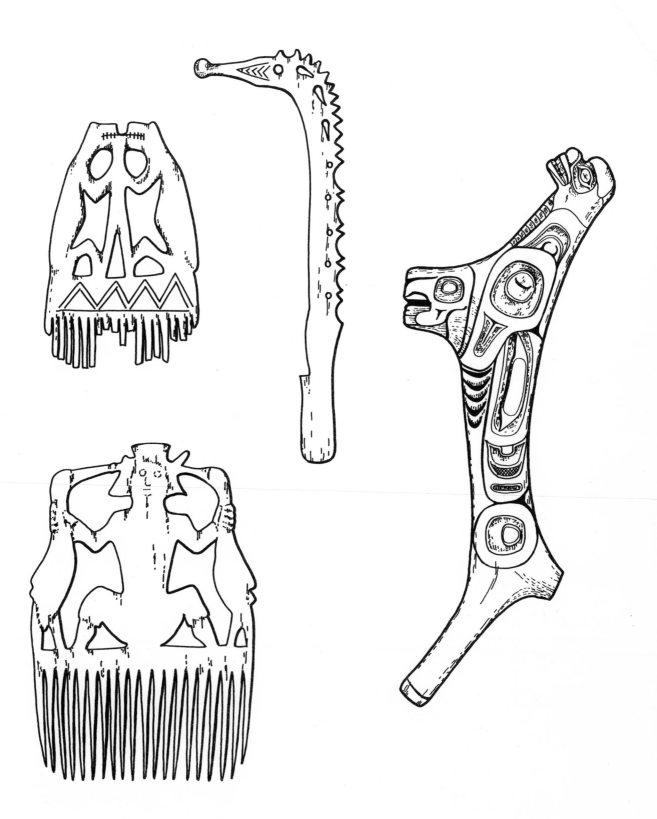

63 LEFT 18th-century antler combs, RIGHT 19th-century antler drum stick and club.

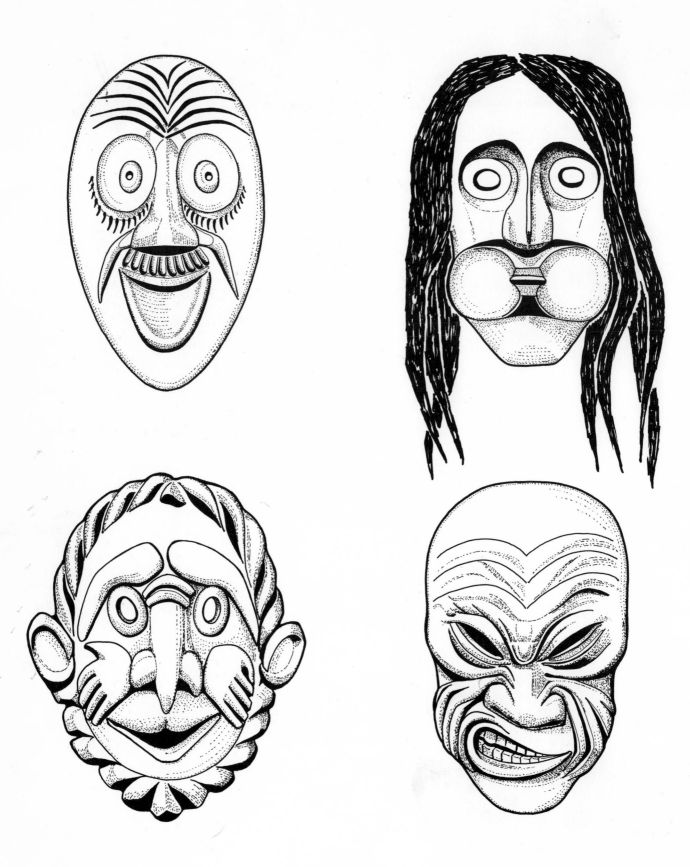

64 Carved wooden masks from the Great Lakes: TOP False Face Society masks, BOTTOM
RIGHT Iroquois clown's mask. BOTTOM LEFT Kwakiutl Noohlmahl mask from Vancouver Island.

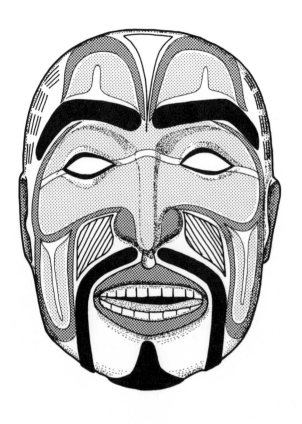
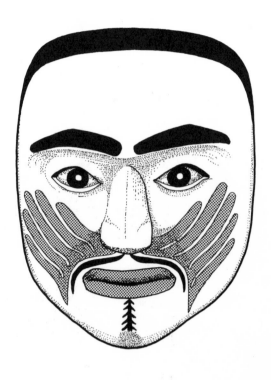
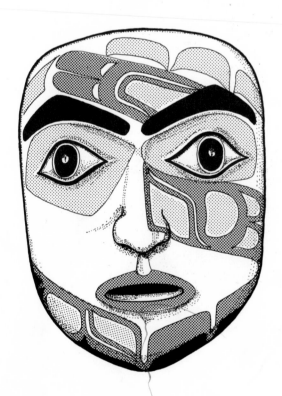
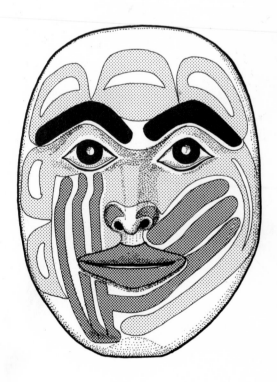

65 Painted wooden masks from the North-west coast.

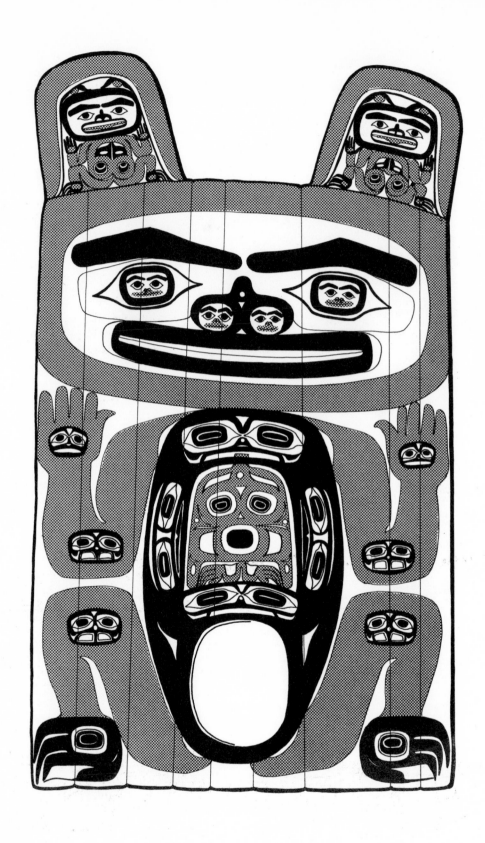

66 House partition of cedar wood planks painted with a design of the Grizzly Bear in black and red. Tlingit, the North-west Coast. *c.*1840.

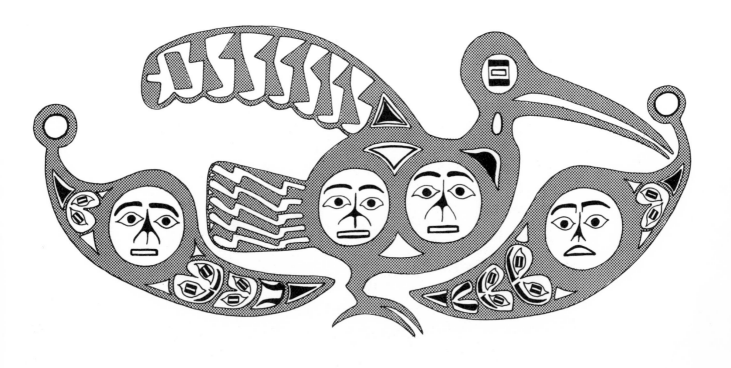

67 Painted design representing the Raven and perhaps two flat-fish on an 18th-century Nootkan semicircular cloak woven from cedar bark and nettle fibre. The patterns BELOW border the curved edges of similar cloaks. The North-west Coast.

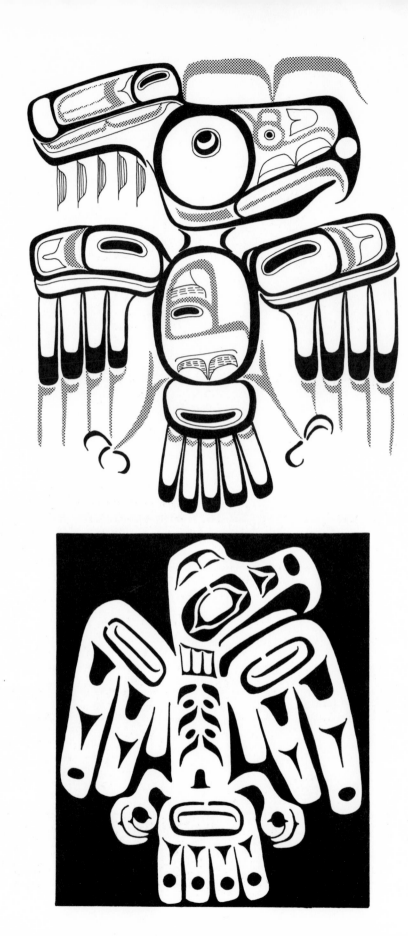

68 The Eagle crest: TOP painted in black and red on a wooden drum; BELOW the design is appliquéd in red flannel on a dance shirt. The vital internal organs are shown in these designs. Haida, the North-west Coast.

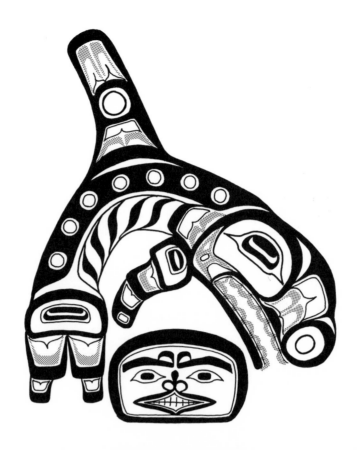

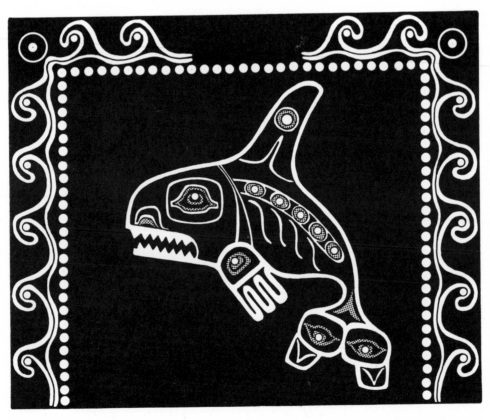

69 The Killer Whale crest: TOP the whale jumping over a rock is a painted design from a 19th-century ceremonial shirt while the design BELOW is made up of appliqué and pearl buttons on a 20th-century blanket.

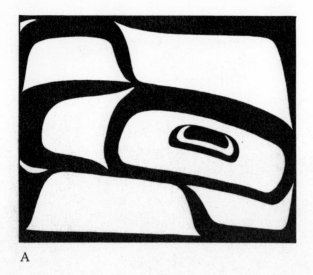

A

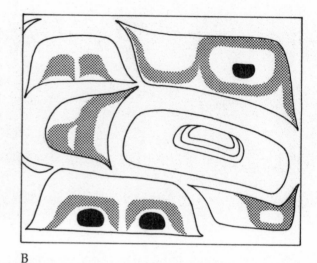

B

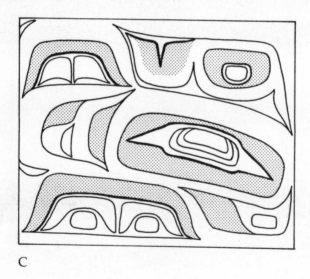

C

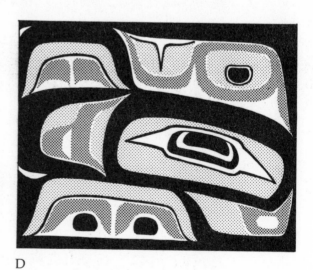

D

70 An analysis of the process of building up a North-west Coast design using the head of a salmon trout as an example (after Bill Holm): A, the primary design elements are painted black and produce the basic divisions; B, the secondary design elements subdivide the areas enclosed by primary elements and are mainly painted red (here represented by a dark screen); C, the tertiary element is the blue-green ground colour (here represented by a light screen); D, the completed design.

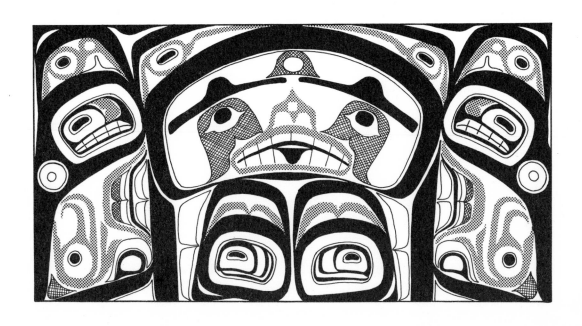

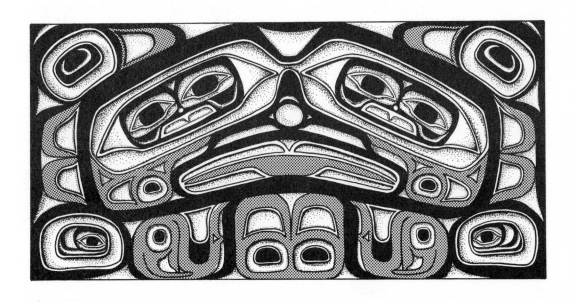

71 Designs on wooden boxes from the northern North-west Coast. The main motif on both is the head of a bear, identified by its large teeth and protruding tongue. The box TOP is painted in black and red, the box BELOW is painted and carved in low relief. Mid-19th century.

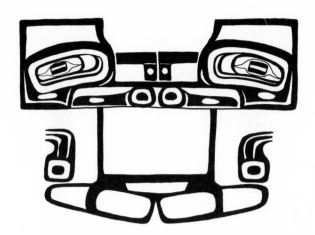

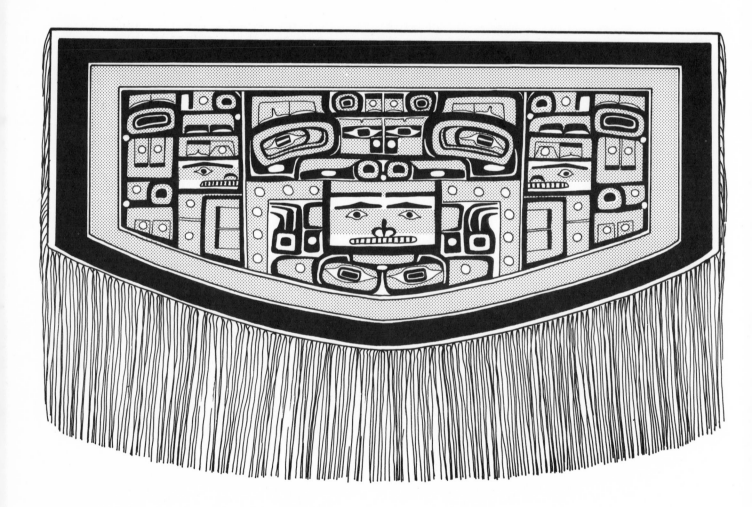

72 Chilkat blanket or cloak. The crest animal is a stylized eagle; the drawing ᴛᴏᴘ attempts to isolate its elements, the head with its hooked beak shown as two opposed profiles, a square body and clawed feet. The North-west Coast. 19th century.

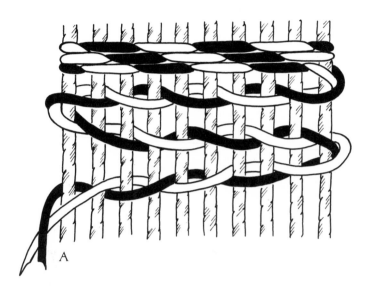

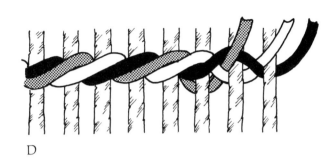

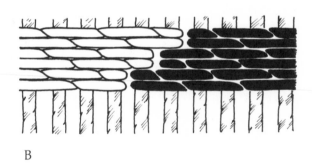

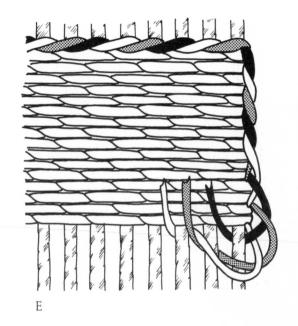

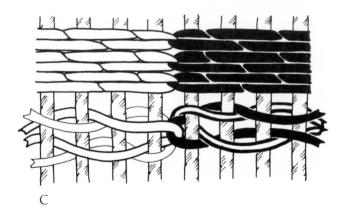

73 Diagrams showing some of the techniques used in weaving Chilkat blankets: A, two-strand twining used for the main fabric; B, diagonal join of two colours; C, interlocking vertical join; D, three-strand braid; E, three-strand braid outlining a shape and F, two rows of braid outlining a circle (after C. Samuel).

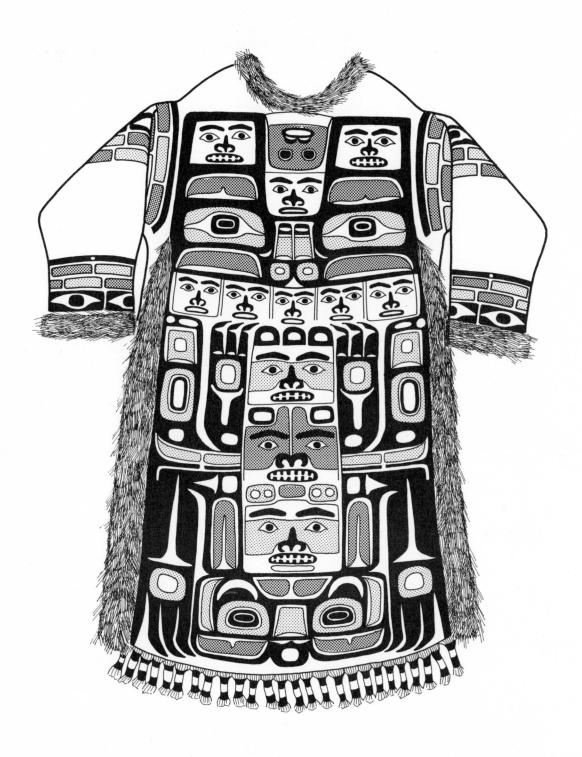

74 Ceremonial shirt woven in the same technique as the Chilkat blankets. Along the
sides are gussets of otter fur. The design represents the Brown Bear, his wife and cub.
Tlingit, Yakutat, Alaska.

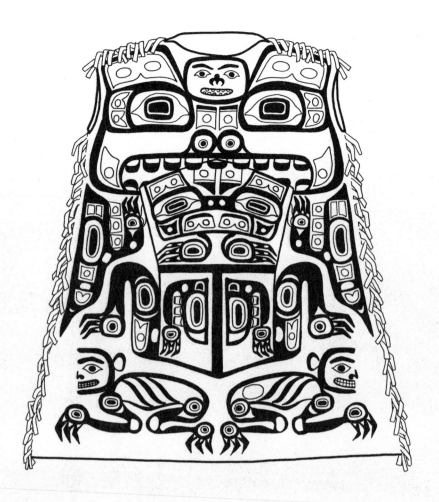

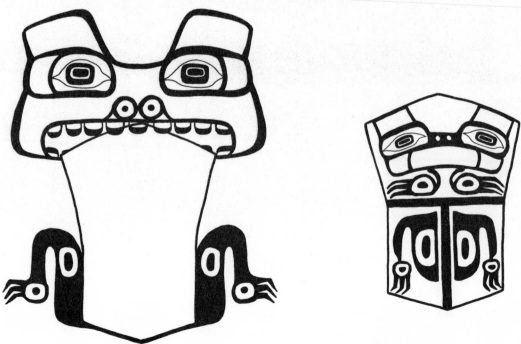

75 Ceremonial skin tunic painted in red and black. The main motif is the Bear, its body covered by a 'copper', an important ritual object which in turn is decorated with an image of the Bear. These two main motifs are shown separately. Tlingit, the North-west Coast. *c.*1890.

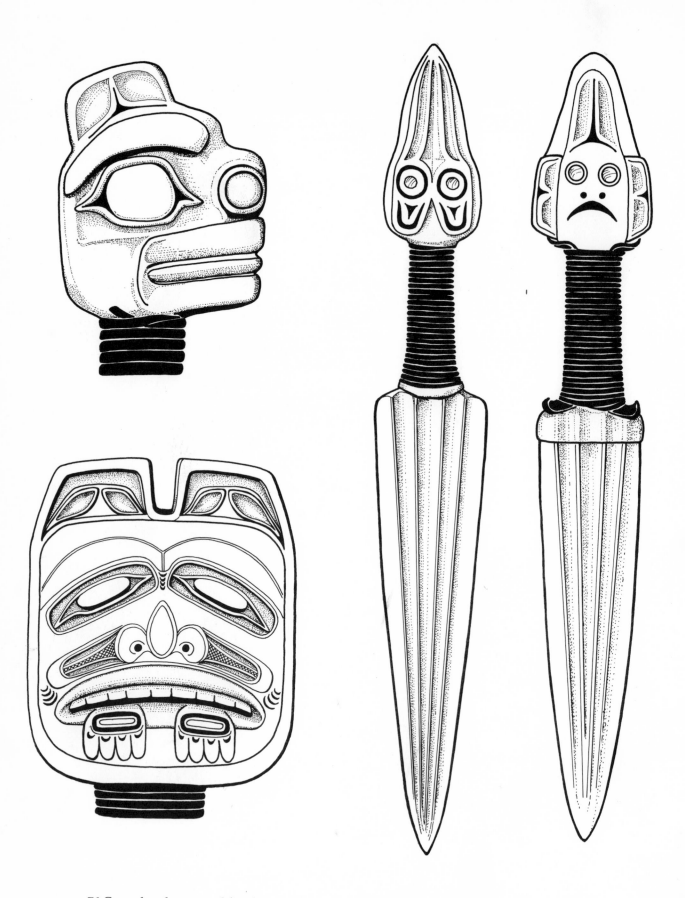

76 Carved and engraved finials and knives in steel, copper and wood. The motifs are the heads of bears and dogfish. Tlingit, the North-west Coast. 19th century.

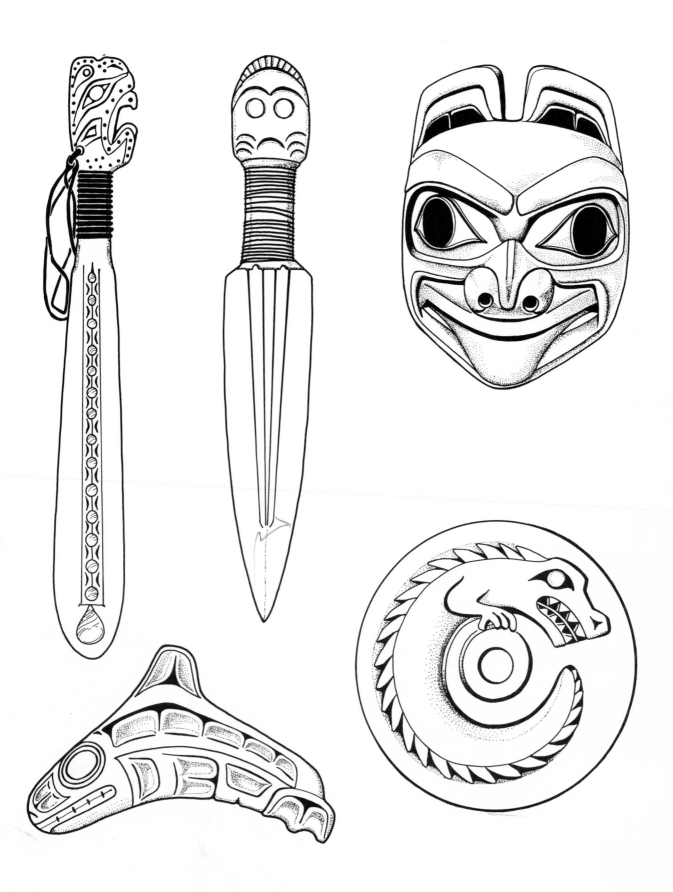

77 Carvings in wood, bone and antler from the North-west Coast. 18th — 19th centuries.

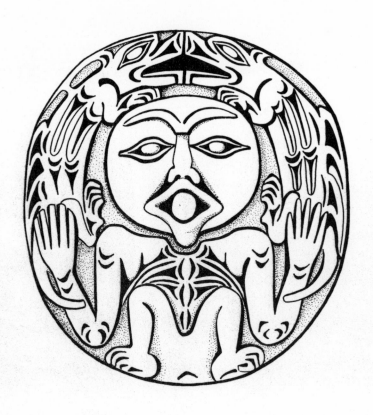

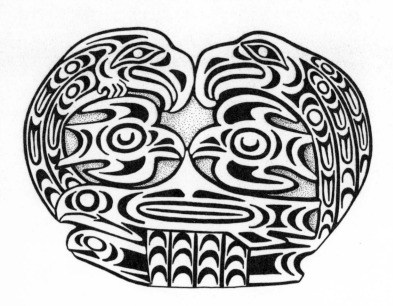

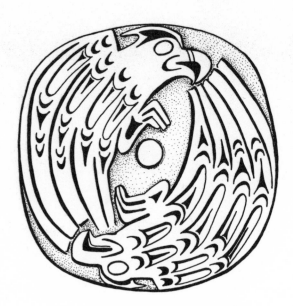

78 TOP and BOTTOM RIGHT Spindle-whorls carved in maple wood. BOTTOM LEFT A human face made up of six birds carved in horn on a rattle. Coast Salish, British Columbia. 19th century.

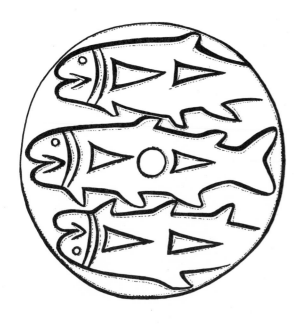

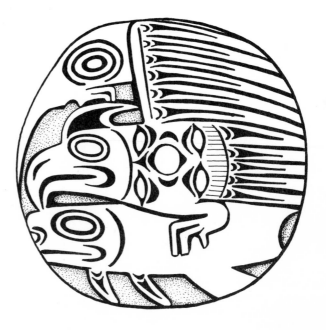

79 Spindle-whorls carved in maple wood. Coast Salish, British Columbia. 19th century.

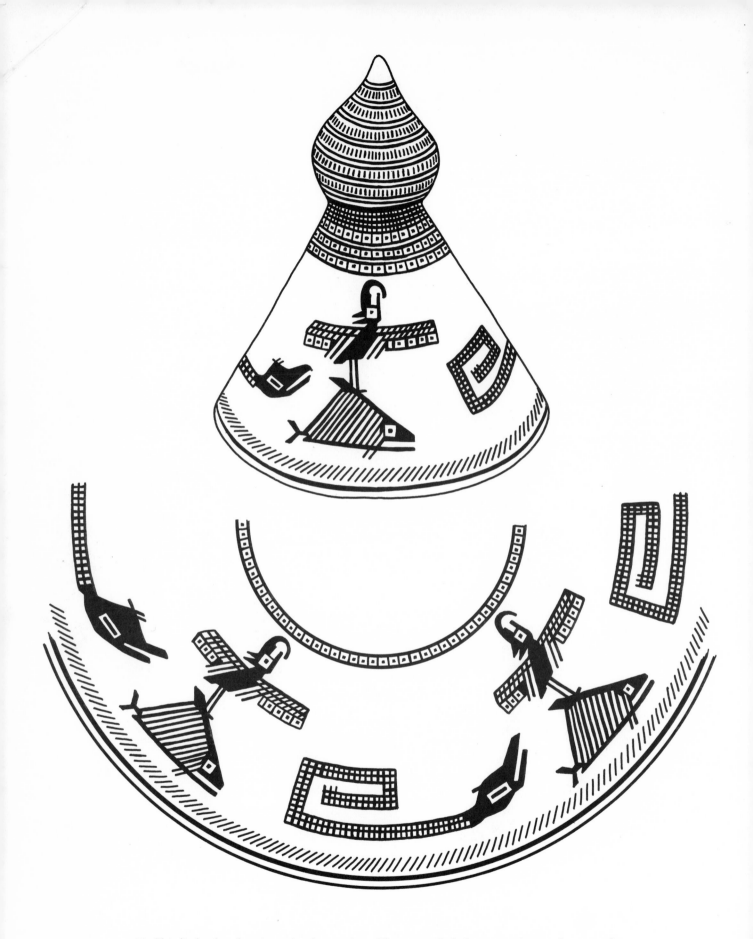

80 Chief's basket hat in twined weaving. The extended drawing shows the complete figurative design of Thunderbirds and Lightning Serpents hunting whales. Vancouver Island. 18th century.

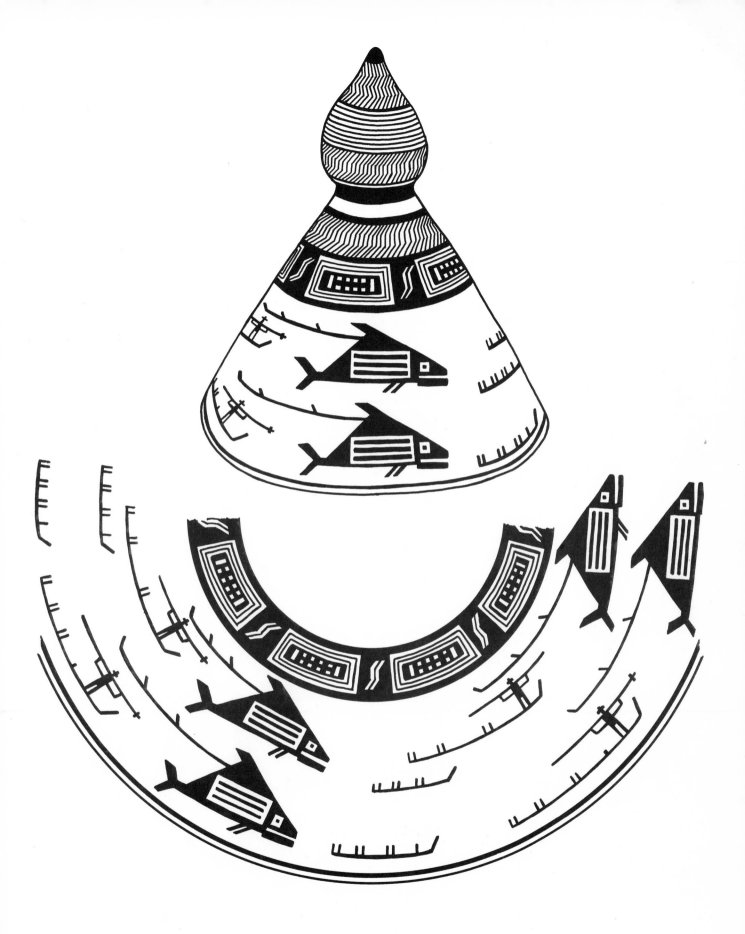

81 Chief's basket hat in twined weaving. The extended drawing shows the complete figurative design representing a whale hunt with harpoons from canoes. Vancouver Island. 18th century.

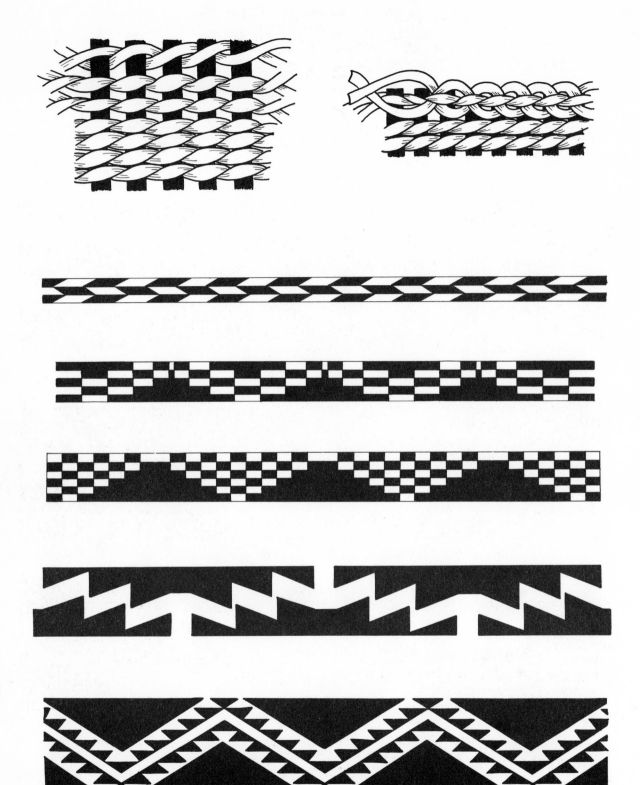

82 The diagram LEFT illustrates the principle of twined weaving in basketry. The diagram RIGHT shows one of the many methods used to finish off the rim of baskets. BELOW are some patterns from baskets woven by this method which favours ornament arranged in borders. Pomo, California. 19th century.

83 The diagram illustrates the principle of diagonally twined weaving in basketry. BELOW are some examples of basket patterns which arise naturally from the use of this method. Pomo, California. 19th century.

84 – 85 Patterns from straight-sided baskets in plain twined weaving. The horizontal stripes and borders are produced in the weaving, other elements are superimposed in false embroidery. Tlingit, the North-west Coast. 19th century.

86 Geometric repeat patterns from baskets in twined weaving and false embroidery.
Tlingit, the North-west Coast. 19th century.

87 Repeat patterns from baskets like that shown CENTRE. The pattern of this basket is shown in the extended drawing BELOW. Tlingit, the North-west Coast. 19th – 20th century.

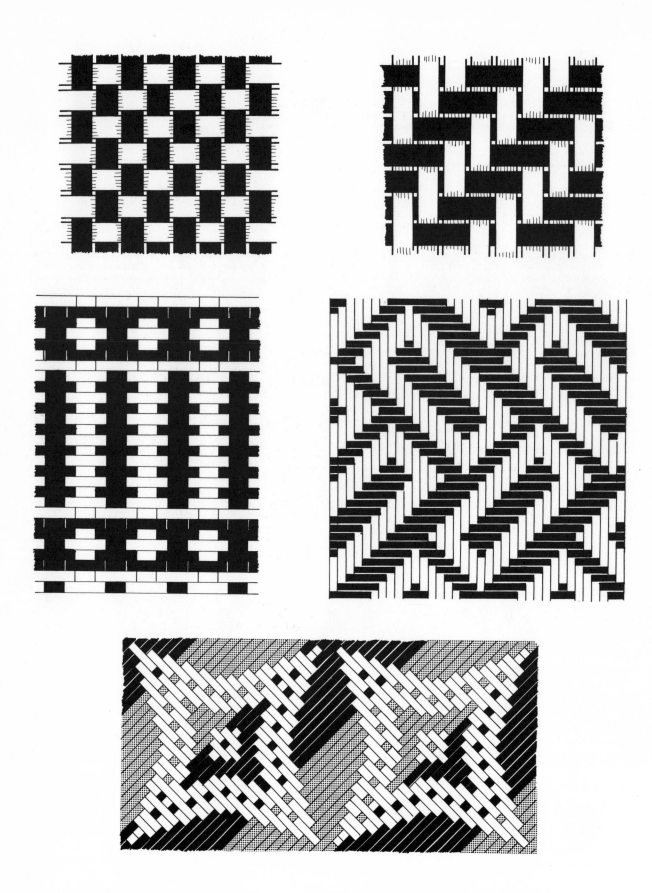

88 The diagrams TOP illustrate the principles of simple chequer work and twill work in basketry. BELOW are examples of patterns on baskets made in these techniques. The South-east. 20th century.

89 The diagram illustrates the principle of wicker work weaving in basketry. The design on a basket tray made by this method is shown ABOVE. Hopi, Arizona. 20th century.

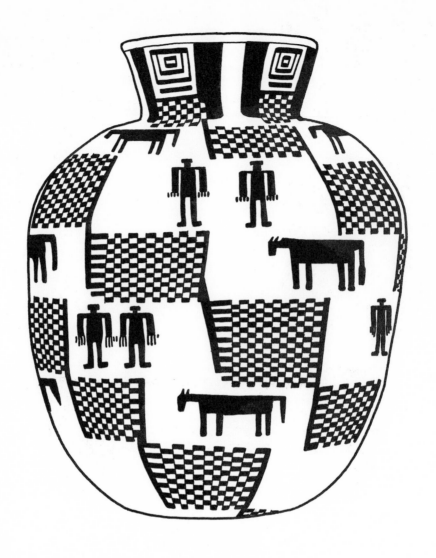

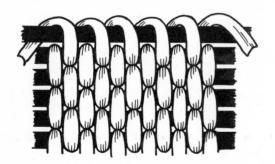 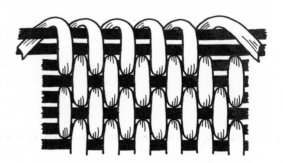

90 The diagrams illustrate the principle of coiled basket sewing: LEFT on a one-rod foundation, RIGHT on a two-rod foundation. The basket ABOVE is a large grain storage vessel made by the coiled method. Apache, Arizona. 19th century.

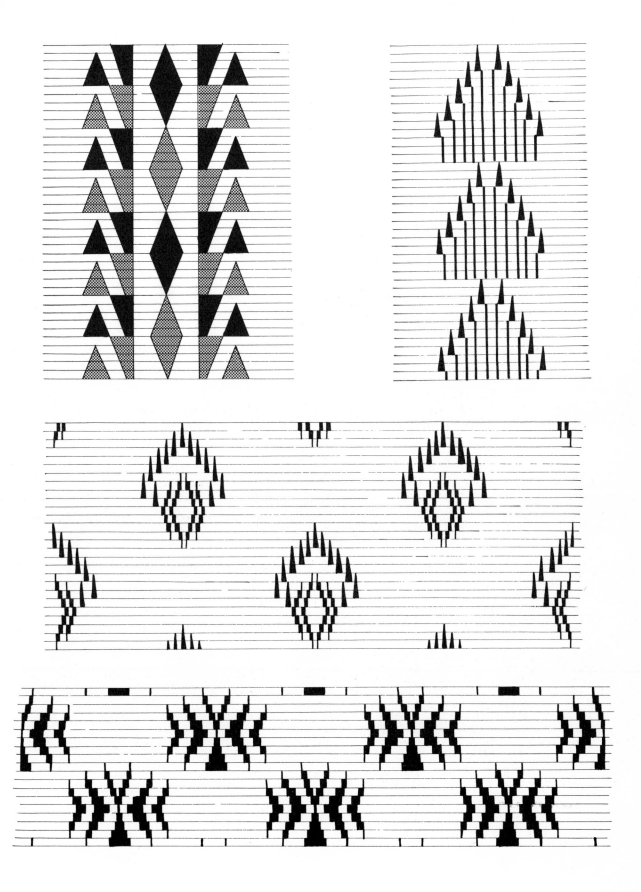

91 Motifs and repeat patterns from coiled baskets by Datsolalee, a Washo basket-maker (1831 – 1926). The pattern BOTTOM may represent birds in flight.

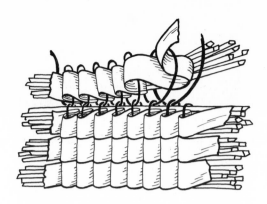

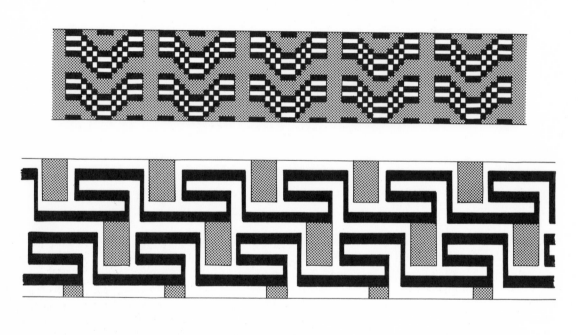

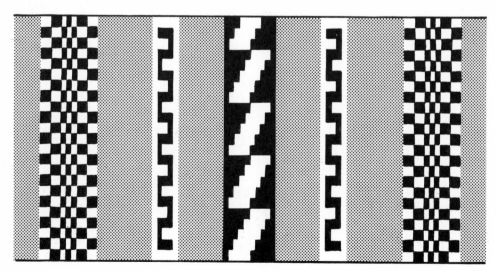

92 The diagram TOP illustrates the principle of coiled and imbricated, or pleated, sewing in basketry. BELOW are some examples of patterns produced by this method on North-west Coast baskets.

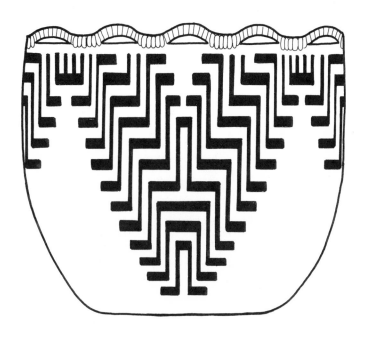

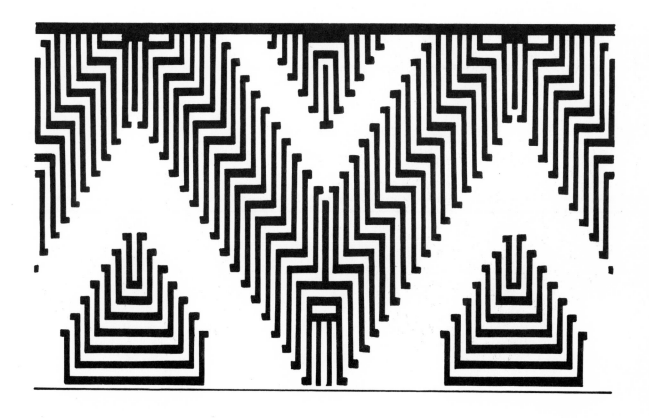

93 TOP Small basket made by the coiled and imbricated method. BELOW An extended drawing of the pattern on a similarly-shaped but much larger basket. Kliketat, Washington. 19th century.

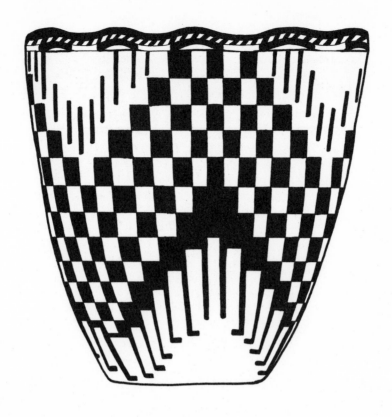

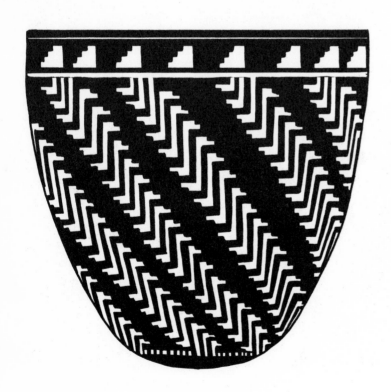

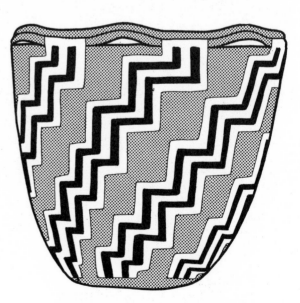

94 — 95 Baskets and basket patterns from the North-west coast.

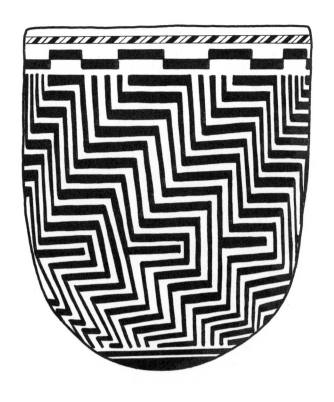

96 — 97 Designs on basket bowls in coiled sewing by the Pima and Papago Indians of Arizona. The principles behind these varied patterns are simple and based on the spiral and radiating elements which arise naturally from the coiling process. 19th — 20th centuries.

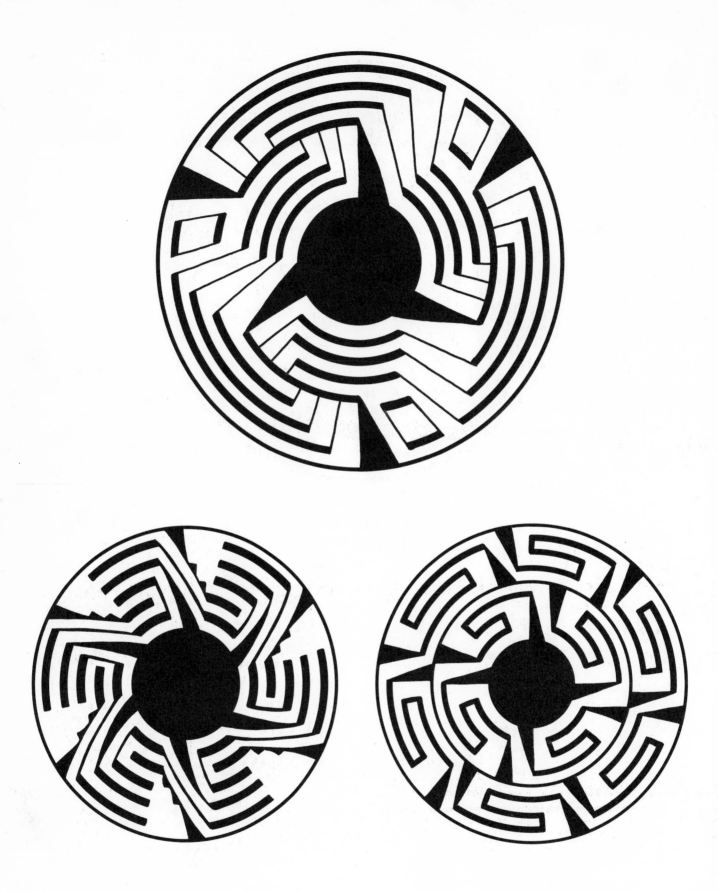

98 – 99 Designs on basket bowls in coiled sewing by the Pima and Papago Indians of Arizona. The designs are based on the simple key pattern, but the divisions into three, four, five and six help to produce rich variations. 19th century.

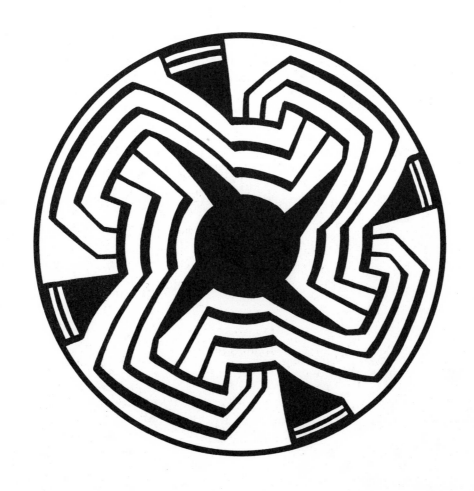

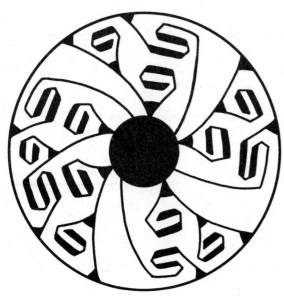

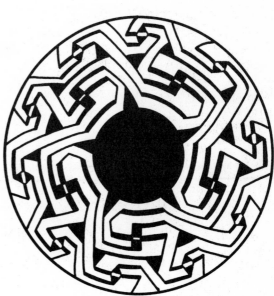

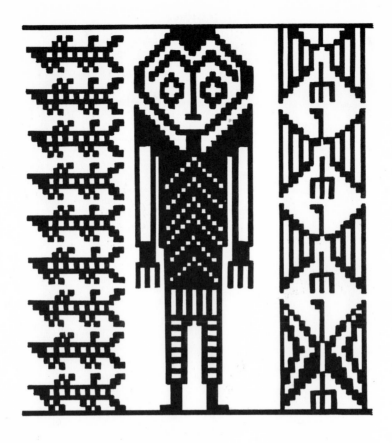

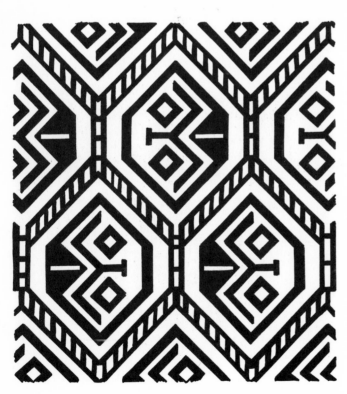

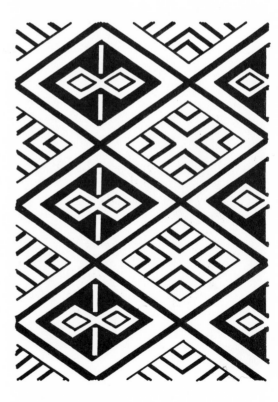

100 Designs on bags in twined weaving by the Wishram and Wasco Indians of Oregon and Washington. 19th century.